IMAGES
of America

WILLOUGHBY LAKE

IMAGES
of America

WILLOUGHBY LAKE

Dolores E. Chamberlain

ARCADIA
PUBLISHING

Published by Arcadia Publishing
Charleston, South Carolina

Library of Congress Control Number: 2017964455

For all general information, please contact Arcadia Publishing:
Telephone 843-853-2070
Fax 843-853-0044
E-mail sales@arcadiapublishing.com
For customer service and orders:
Toll-Free 1-888-313-2665

Visit us on the Internet at www.arcadiapublishing.com

This book is dedicated to all the residents of Westmore,
Vermont, and to all the summer visitors who enjoy and have
enjoyed in the past the unprecedented beauty and tranquility
of the one-of-a-kind area that is Lake Willoughby.

CONTENTS

ACKNOWLEDGMENTS

There are so many people that I need to acknowledge, and I hardly know where to begin. First of all, thank you so much, Elaine Bandy, Greg Gallagher, Mildred Davis, Marion "Midge" Hunt, and my husband, Jim Chamberlain, for firsthand accounts of personal memories and information related to the Willoughby Lake area. Thanks also go to Kathy Frye and Steve Morse, for their generosity in lending me the many postcards and photographs from their extensive collections; Ken Barber, for giving me access to his wonderful photographs that are adding so much to this book; Jim and Sandy Towns from the Willoughby Store, for their printed material and pictures that give this book its added boost and appeal; the Glover Historical Society; and the Wayne Alexander family and Joan Alexander and Jesse Dion. A big thank-you goes to Dan Guest, for scanning all the pictures, which was a tremendous help; Bob Guest, for relating his experiences in scuba diving in Lake Willoughby; and *New England Construction* magazine, a member of Associated Construction Publications, for the information on the shelf highway construction, reprinted with their permission. Also, my thanks go to the Orleans County Historical Society for allowing me to use portions of *Willoughby Lake: Legends and Legacies* by Harriet F. Fisher.

INTRODUCTION

A lake is the landscape's most beautiful and expressive feature.

—Henry David Thoreau

Since earliest times in Westmore, the boats, cars and other forms of transportation have evolved. Horse-drawn wagons, both for transporting people and goods from one place to another, reflected a quieter and less hectic lifestyle. As time went on, women no longer traveled in their long dresses and matching hats, even when gliding across the water of the lake in canoes while sporting a parasol to protect them from the hot sun beating down on them. Hemlines eventually were shorter as they climbed in and out of cars, now the mode of transportation.

In and around the lake, many changes have been made over the years. An ambitious project in 1852 by Peter Gilman was carving out a road along the shores of Willoughby. When funding ran out, he used his own money to finish the project, showing the ingenuity and perseverance to finish what he started. Although little more than a dirt path, it was the beginning of a way to circumnavigate the miles around the lake. His project paved the way for the better and safer road, which was constructed in 1955, located primarily on a higher level above the Gilman road; it was a very difficult process shearing steep cliffs and widening the road. Of course, at this time, industrial construction equipment aided the men in this great work.

Occasional landslides hindered the roadwork, and even in recent years, especially after our harsh winters, motorists have to be very careful of falling rocks and boulders, which can block the roads, and remain wary to avoid this potential hazard.

In each season, the lake and surrounding area wears a different look. In winter, the heavy dark clouds cover Mount Pisgah and Mount Hor like a heavy blanket, rarely letting any sunlight onto the frigid waters. On the first of January each year, several hardy and daring souls brave the water and plunge for a worthy cause. Springtime warmth evaporates the shroud of winter, and various shades of green begin to emerge from their long slumber and adorn the fields and mountains. Summer brings out the brilliant emerald greens as the trees display their beauty all around Willoughby. Not to be outdone, the golden, red, and yellow hues emerge as jewels from a treasure chest that has been thrown open for all to enjoy in the glorious season of autumn in Vermont. No matter what time of year, Willoughby Lake is always at its best. Sometimes, the water is calm and gently kisses the beaches; while at other times, the waves are hostile as they buffet anyone who dares to be out in a boat. The lake appears alive, almost as a living, breathing entity.

Westmore remains a quiet, reserved rural town in northeastern Vermont. The tranquility is felt by local residents and visitors alike. A church, community building, grocery store, and deli, along with year-round homes, seasonal camps, boat launches, and many other out-of-the way attractions, keep this place a friendly thriving area. One of the favorite places to visit is Sentinel Rock State Park, which offers a sensational view overlooking the beautiful valleys and a partial glimpse of Willoughby Lake far below.

A short trail into a wooded area brings hikers to a region known as Balance Rock. A series of large, glacially deposited boulders is a fascinating place to explore. The peace and quiet is almost deafening, in a sense. The location is a sheltered glen of the forest on an old county road.

The winter season offers challenges for those who dare to scale the vertical cliffs of Mount Pisgah with their ropes and pulleys as they rise high up to test their ice climbing skills. While in warmer months, diverse paths lead to hidden waterfalls, small ponds, and even a pioneer burial ground. Many unusual plants are hidden away along the paths.

The lure of majestic Willoughby Lake, the sparkling jewel of Westmore, offers visitors an array of activities and adventures. But still the area maintains its rural atmosphere. Come experience the sights of Willoughby Lake in Westmore for yourself. This place is not to be missed!

Ever since the world was created,
God's invisible hand, his eternal
Power and divine nature, have been
Seen clearly, by everything that
Has been made in this world, so that
Everyone will know.

—Romans 1:20

One

MANY FACES
OF WILLOUGHBY

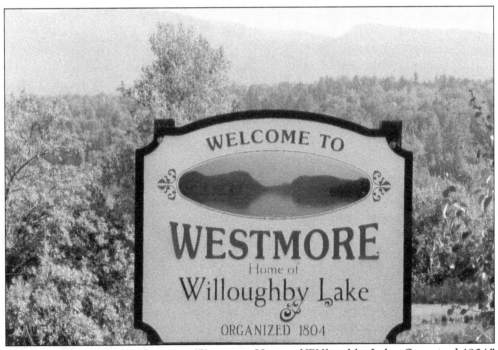

A current sign reads, "Welcome to Westmore, Home of Willoughby Lake. Organized 1804." (Author's collection.)

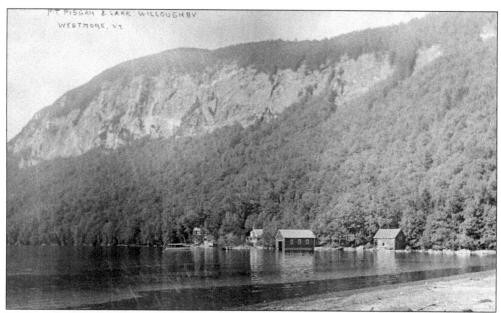

Right in the middle of the cliffs high on Mount Pisgah is the natural formation resembling the letter *S*. This postcard is dated May 4, 1915, and was sent to Mrs. F.H. Smith in Randolph, Vermont. It reads, "Dear Mrs. Smith, Just a line to know if you have got your auto yet. If you have, be sure and come and see us. We have not been out in ours but once I am feeling lots better this Spring. Hope this finds you all well. Respectfully, Mrs. C.W.S." (Courtesy of Steve Morse.)

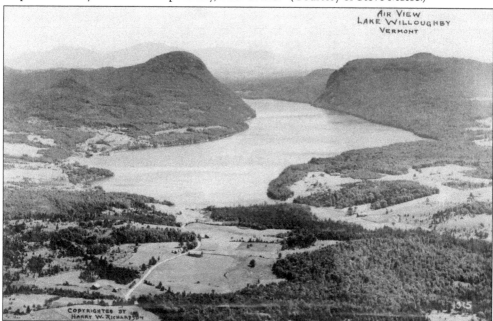

This is an aerial view of Lake Willoughby, which lies between two mountains (Hor and Pisgah) and is often described as similar to a Swiss lake. It is nearly five miles long, providing a good venue for water sports and fishing. Located north of Lyndonville, Vermont, a scenic drive along Vermont Route 5A suggests that only a divine hand could have carved out such a beautiful sight. (Courtesy of Greg Gallagher.)

This nice elevated view from Mount Pisgah on Lake Willoughby shows some of the steep cliffs on the mountainside. The postcard was sent to Mell ? in Spring Cove, Pennsylvania, and is dated August 1924. The message on the back of the card reads, "Dear Aunt Mell, I miss you very much. It was raining at lunch, but now it's stopped. Love, Betty." (Courtesy of Steve Morse.)

Although the lake can be beautiful on sunny days, dark days highlight the power and strength of this impressive lake. Tranquil Lake Willoughby features camps and a boathouse on the far shore. Note the prominent S on the cliffs of Mount Pisgah. It apparently was formed by the trees and rocks surrounding the area. (Author's collection.)

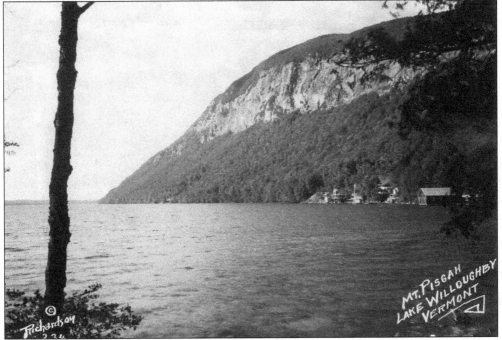

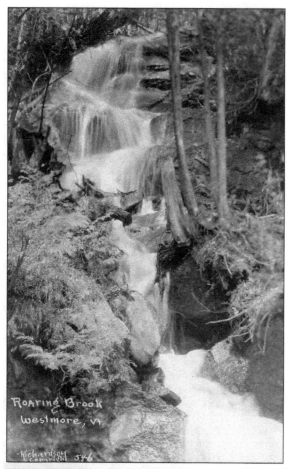

Roaring Brook cascades down the hillside. Still a popular sight along Route 5A, the falls now has a "fence" in front of it and water runs through a culvert under the road. (Courtesy of Elaine Bandy.)

The rippling waters of Willoughby Lake are nearly always clear and icy cold. One can always expect a refreshing swim in this lake. Mount Pisgah (on the left) and Mount Hor (on the right) create a picture-perfect frame for Willoughby. (Courtesy of Kathy Frye.)

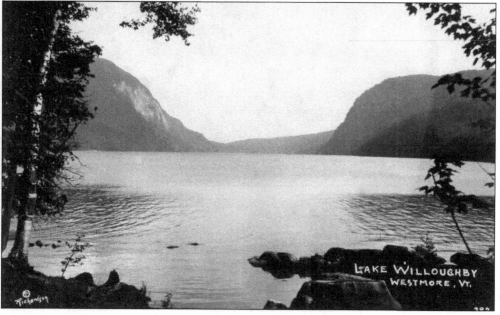

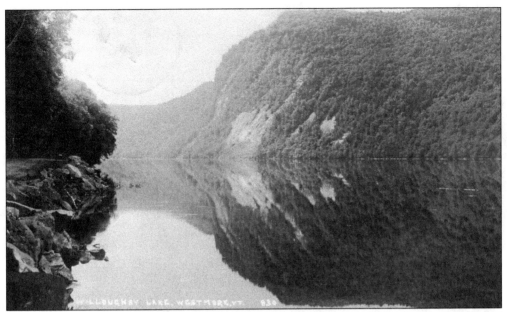

What a nice reflection of Lake Willoughby (where the depth has just been discovered to be 337 feet at its deepest point)! The card was postmarked at Orleans, August 15, 1939, and was sent to a Mrs. Lorenzo Horiullou(?) in Meriden, Connecticut. It reads, "Hello to you all! Have you been to the World's Fair yet? The summer has passed so rapidly. Suppose we'll all be back in Connecticut soon. Sam and Ted love the water. Hope to see you soon. Iris G." (Courtesy of Steve Morse.)

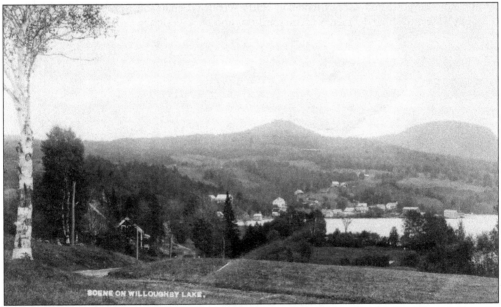

Many homes and camps have sprung up along Willoughby Lake. The back of this card reads, "Up where the grass grows a little greener / Up where the snow lasts a little longer. / Up where the winds blow a little number. / Up where the mountain peaks rise a little higher. / Up where the unpolluted waters rise, / Up where health is man's best riches. / Up where the heart beats a little stronger. / Up where the hand clasp is just a little warmer. / Up where the lonesome pine its mighty requiem sighs. / That's where Vermont comes in." (Courtesy of Steve Morse.)

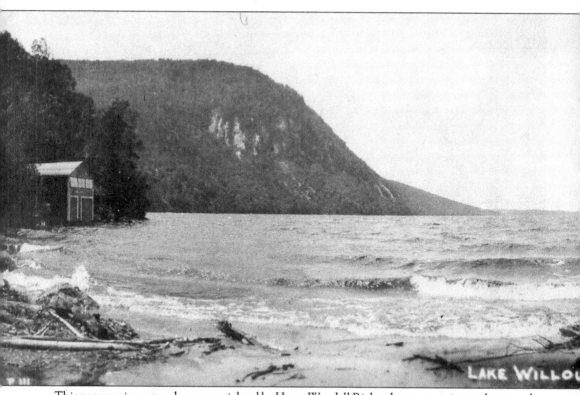

LAKE WILLOU

This panoramic postcard was copyrighted by Harry Wendell Richardson, a prominent photographer. Choppy waters wash up debris along the southern end of Willoughby Beach, with boathouses at

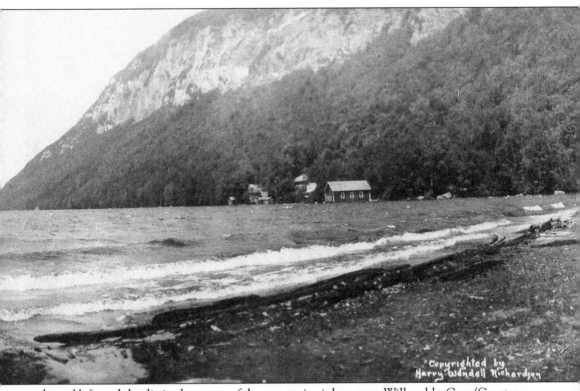

right and left, and the dip in the center of the mountains is known as Willoughby Gap. (Courtesy of Kathy Frye.)

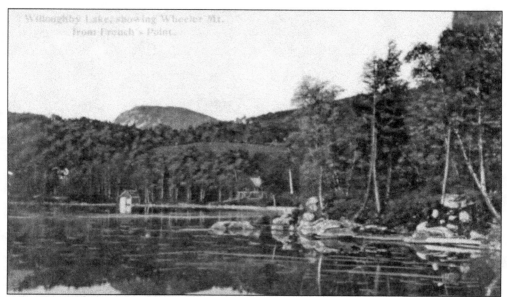

Willoughby Lake showcases Wheeler Mountain from French's Point in a nice secluded cove. The card was sent to Mrs. A.H. Rexford in East Highgate, Vermont, and reads, "Grandma and I came home yesterday. Belle and Doctor hated to ride home alone. We had a splendid time while away and saw lots of relatives I had never met before. Was awfully sorry not to have seen you. Suppose you are all torn up now. We have varnished the dining room today. With love, Leah." The card is dated May 18, 1915. (Courtesy of Steve Morse.)

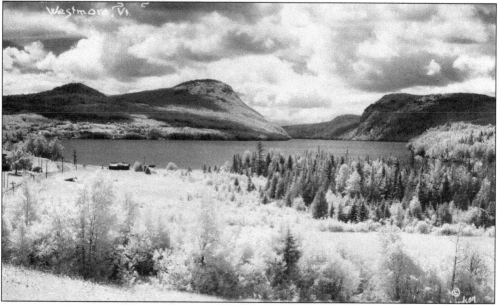

Postmarked Orleans on July 2, 1952 and sent to Mrs. John J. Way, 84 Howard Avenue, Brookline, Massachusetts, the card reads, "This is apparently lovely country even in winter. I came to Lyndonville with the Vermont Bird and Botanical Club and we're here afterwards for a rest. Am the only woman as yet. Have to go out for lunch and dinner. Am writing this on the roadside so I can visit the little restaurant on the way back and mail this in front of the country store where I sometimes get dessert. With regards to all, Bertha E. Davis." (Courtesy of Steve Morse.)

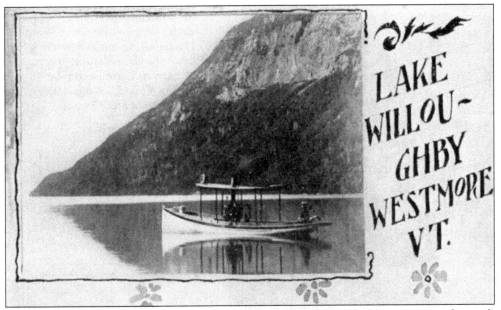

This small group is enjoying a trip along the shores of the lake. It looks like a very nice day, with mirrored reflections on the surface of the water. (Courtesy of Steve Morse.)

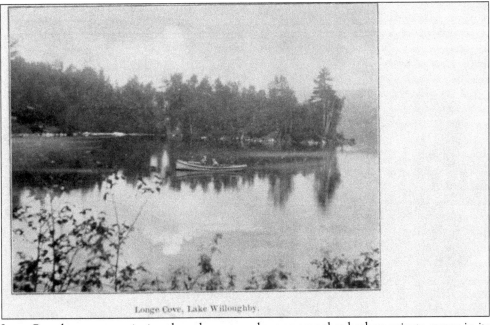

Longe Cove, Lake Willoughby.

Long Cove boaters are enjoying the calm waters along an area that harbors private camps in its seclusion on Willoughby Lake. (Courtesy of Steve Morse.)

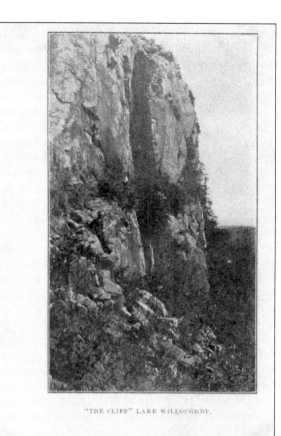

"THE CLIFF" LAKE WILLOUGHBY.

Vertical cliffs are evident, as shown in this image of the side of Mount Hor depicting quite a deep crack down the center. This is just one of many such features on the cliffs of Willoughby's mountains. (Courtesy of Steve Morse.)

An early farm sits in the center field beyond the lake. Contents of the message read, "From Cottage 'Sans South' Westmore, Vermont on August 3, 1911. Write soon or come if you can. I shall be here through August. Love from Grammy. I am still charmed with this cottage and the enormous rocks." (Courtesy of Steve Morse.)

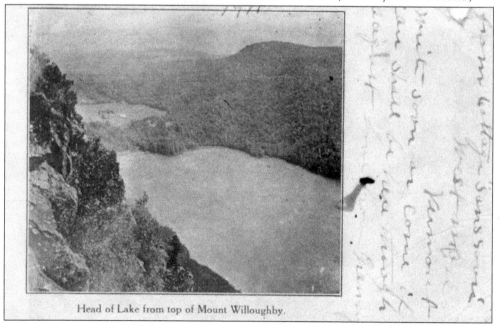

Head of Lake from top of Mount Willoughby.

Heavy forests once surrounded beautiful Willoughby Lake in Westmore, Vermont, as this early card shows. Farmland was cleared later on. (Courtesy of Steve Morse.)

This view makes the lake look like a pond. Here is a tranquil scene on Willoughby Lake with an unpaved road in the foreground. Camp Songadeewin is just visible on the hill in the center. The card is postmarked April 27, 1915, and was sent to Mrs. S.L. Lantz in West Somerville, Massachusetts. The message on the back reads, "Dear Friend, Arrived at 4:30 a.m. They were waiting at the depot for me. Father went to bed alright. When Glen went to call him, found him dead in bed just as he went to sleep. Glad he is out here. Funeral at home tomorrow at 1:00 p.m. Regards to all. Will write later. Lew." (Courtesy of Steve Morse.)

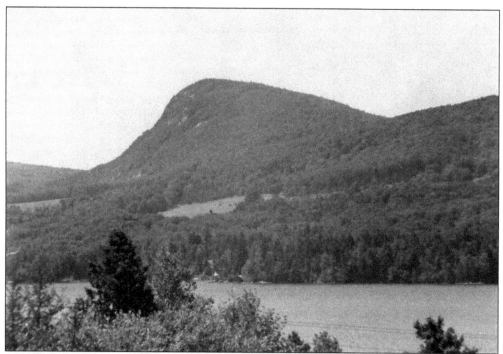

Even though forests once surrounded beautiful Willoughby Lake, here Wheeler Mountain rises high above the majestic lake. (Author's collection.)

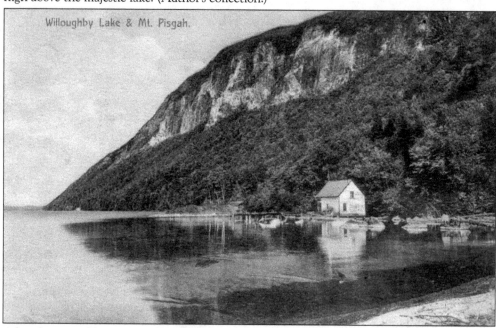

Willoughby Lake & Mt. Pisgah.

A boathouse and logs awaiting the sawmill are reflected in beautiful Lake Willoughby. The card is stamped at West Burke, Vermont, July 8, 1915, and is addressed to Mrs. Susie E. Tate, Barton, Vermont. It reads, "Hello! How are all the folks? I reached here at eight o'clock Tuesday night. I like the place very well. This is a view of the lake. Near us the steep mountain is Mount Pisgah. Our address is Pisgah Lodge, West Burke, Vermont. Rupert." (Courtesy of Steve Morse.)

This is a not-so-apparent profile of the "Old Man of Mt. Hor" on Lake Willoughby, Vermont. (Courtesy of Steve Morse.)

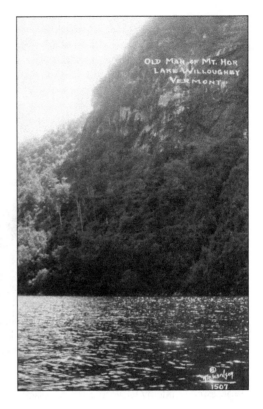

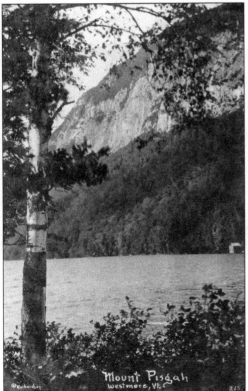

Here is a glimpse of Mount Pisgah in Westmore, Vermont. The card is dated June 24, 1924, and was sent to Mr. and Mrs. E. Carpenter, 352 West Street, Mansfield, Massachusetts. The postmark is from Newport, Vermont, on a Tuesday at 9:00 a.m. The message included reads, "Dear Friends, Hope that you both feel as well as usual. We are feeling fine and having a wonderful trip. Last night we camped almost where this picture was taken. Papa and Mama stayed at Pisgah Lodge—only a short distance away. Wonderful scenery. We cooked our breakfast on the beach at Willoughby Lake at 7:25. We now go to Derby Line and then to White Mountains. Best wishes, XX M.V.E." (Courtesy of Steve Morse.)

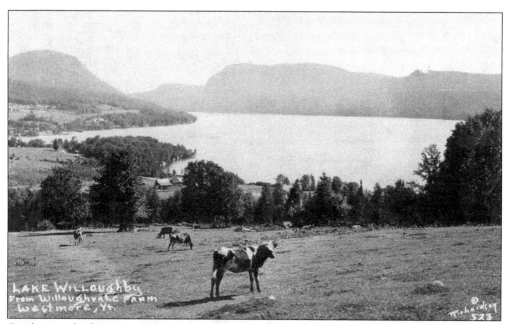

Cattle graze high up on the hillside overlooking Willoughby Lake. Farms once were common and numerous all around Vermont. This postcard from the early 1900s reads, "Please note nice northern Vermont fauna in the foreground. I am going to Northampton on the midnight Sunday. Arriving at 8:00 a.m. Another fine letter from you! Dottie" This was sent to Roger Bacon at Worcester Academy in Worcester, Massachusetts. (Courtesy of Steve Morse.)

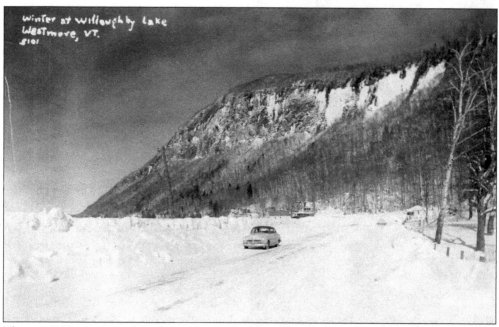

This is a 1950s picture with high snowbanks flanking the road around the lake and ominous dark clouds threatening more to come. (Courtesy of Kathy Frye.)

22

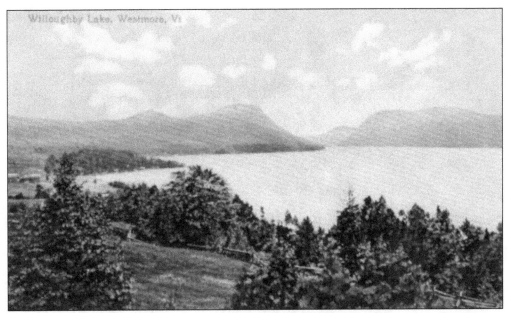

In this scenic photograph are Mount Hor and Pisgah, with Wheeler Mountain in the distance. A few red cabins are shown along the shoreline. The card is stamped Boston, September 16, 1910, and was sent to Mrs. T.G. Crandall of Orleans, Vermont, reading, "Dear Cousin, I was very glad to get your card and are able to write again now. Write me a good long letter. The weather is fine here. My nephew and wife were here all last week and we were on the go every day so I got pretty tired, but think I will get rested after a time. Write soon. With love, Cousin Della." (Courtesy of Kathy Frye.)

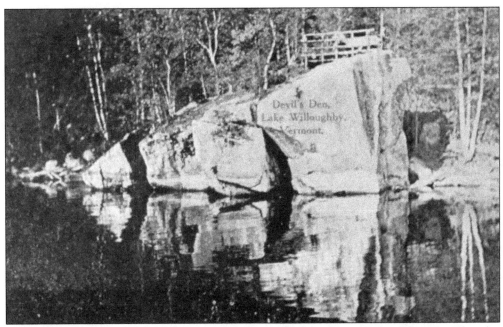

Devil's Rock, or Devil's Den, reflects a face when turned on its side in Willoughby Lake. This also is a popular jumping off place for many daredevils. (Courtesy of Steve Morse.)

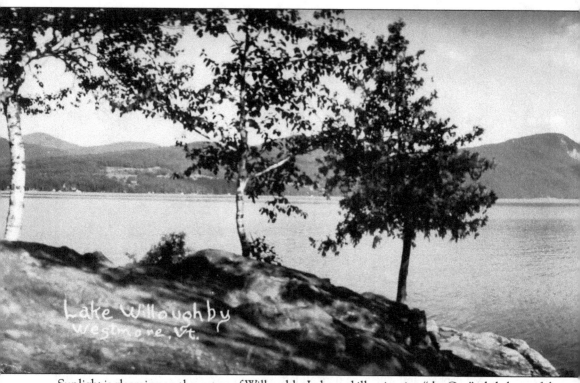

Sunlight is gleaming on the waters of Willoughby Lake and illuminating "the Gap" while beautiful

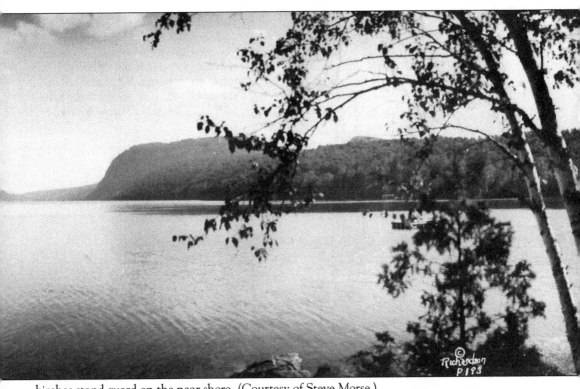

birches stand guard on the near shore. (Courtesy of Steve Morse.)

View from Highway, Lake Willoughby.

Think it will be a lovely night for band concert. Wish I

Postmarked Lyndonville, July 18, 1907, and sent to R.B. Ladd in Lyndonville, Vermont, the message reads, "It must have been a terrible day at home. It was warm enough here. Write and tell me the news. I am now going on the lake. M.R.D." (Courtesy of Steve Morse.)

These three unidentified boys (c. 1920s) are on the shore of the lake at the base of Mount Pisgah. (Courtesy of Steve Morse.)

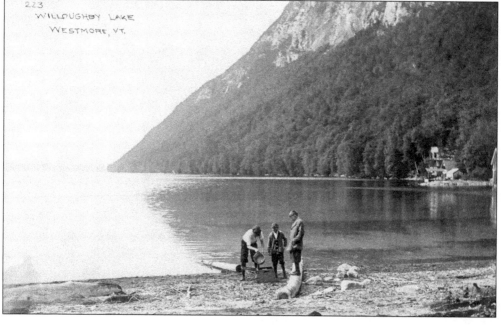

223
WILLOUGHBY LAKE
WESTMORE, VT.

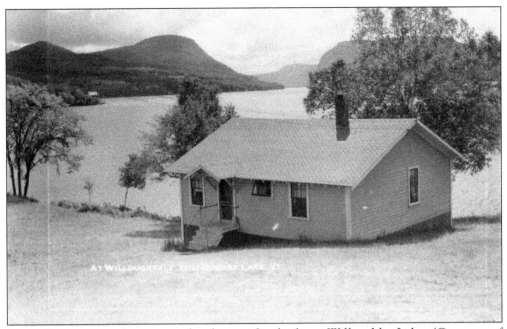

A small cottage evokes quiet solitude on a bank above Willoughby Lake. (Courtesy of Ken Barber.)

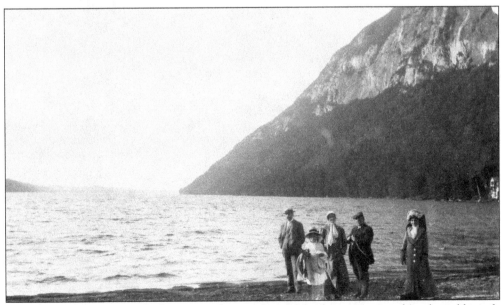

With hats and bonnets and warm coats, the members of this brave group endure the cold winds blowing off the lake to have their picture taken. (Courtesy of Ken Barber.)

Every season is spectacular at Willoughby Lake. This is a rare scene of early Willoughby during the winter season. (Courtesy of Greg Gallagher.)

In July 2017, the late afternoon sun tricks the eyes into seeing the illusion of a castle on the steep cliffs of Mount Pisgah, high above Willoughby Lake. (Author's collection.)

What an excellent view of the lake and Mount Hor, Mount Pisgah, and Wheeler Mountain as a backdrop for the lake! A road runs straight along the lake beside a large field with trees growing in it, making a very beautiful picture indeed, which perfectly exemplifies why Westmore in northeastern Vermont is its own little paradise. (Courtesy of Kathy Frye.)

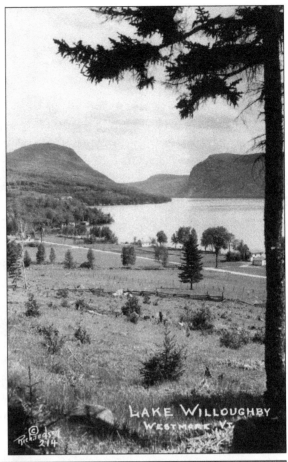

There may be no better way to spend a warm summer day than camping and canoeing on the shores of Willoughby Lake. (Author's collection.)

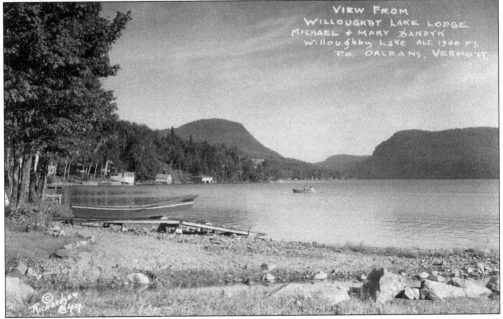

29

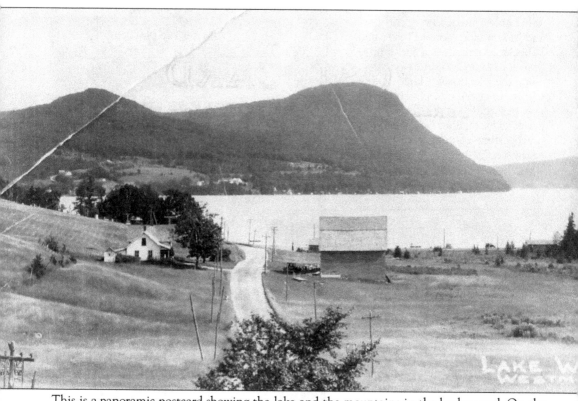

This is a panoramic postcard showing the lake and the mountains in the background. On the hillside on the right is the beautiful Camp Songadeewin, previously owned by a Mrs. Peene. On

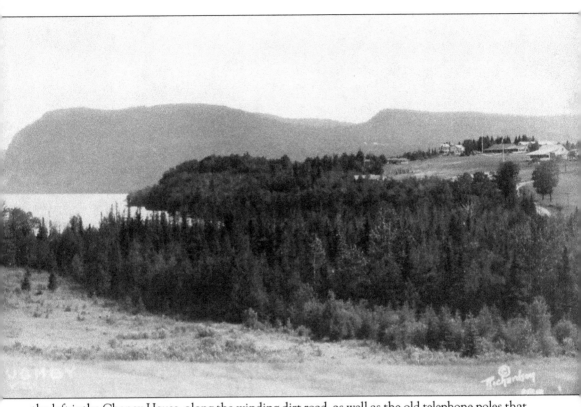

the left is the Cheney House, along the winding dirt road, as well as the old telephone poles that used to line the road. (Courtesy of Kathy Frye.)

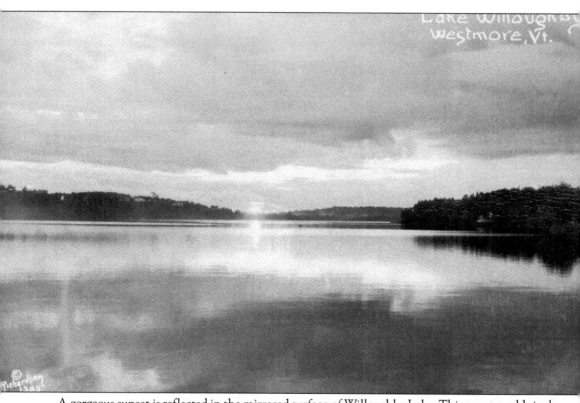

A gorgeous sunset is reflected in the mirrored surface of Willoughby Lake. This scene could rival any sunset in any tropical paradise. (Courtesy of Steve Morse.)

Two

ROADS AROUND THE LAKE

Here is a very early view in Westmore of Willoughby Lake when the area was heavily forested. In later years, farming, such as sheep and dairy farming, would be introduced to the area along with other industries, such as sawmills and recreation. (Courtesy of Greg Gallagher.)

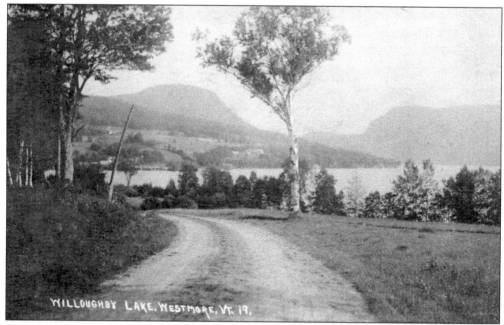

A drive along an old Vermont road more picturesque than this delightful scene approaching Lake Willoughby would be difficult to find. The various types of trees make it even more interesting. (Courtesy of Greg Gallagher.)

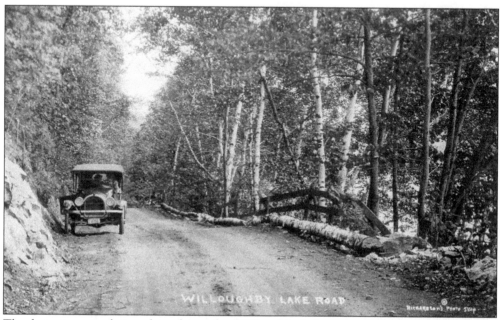

The dense tree population along the road to Willoughby Lake can make it a bit difficult to see the lake from this roadway in Westmore. (Courtesy of Greg Gallagher.)

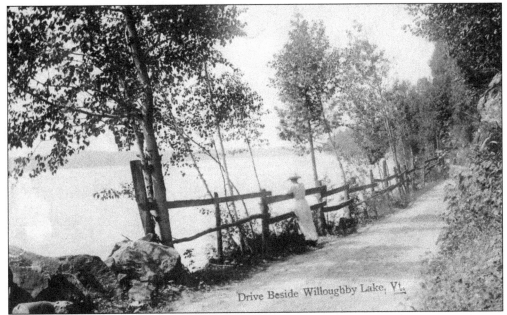

Drive Beside Willoughby Lake, Vt.

This lady in white takes a few leisurely moments to daydream while gazing at beautiful Willoughby Lake. This corduroy road meanders along under the steep cliffs of Mount Pisgah on the old Route 5A. The card is postmarked May 27, 1914, and was sent to Grace Wells. (Courtesy of Elaine Bandy.)

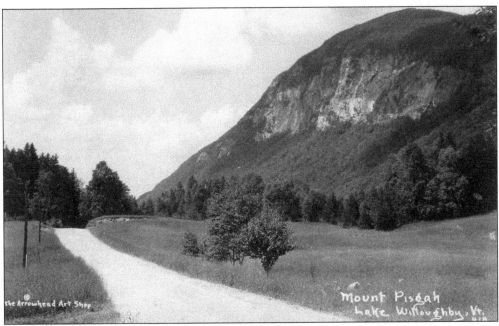

The Arrowhead Art Shop

Mount Pisgah
Lake Willoughby, Vt.

This image was captured on a clear weather day while the photographer was traveling the road to Willoughby Lake and passing the high cliffs of Mount Pisgah. (Courtesy of Steve Morse.)

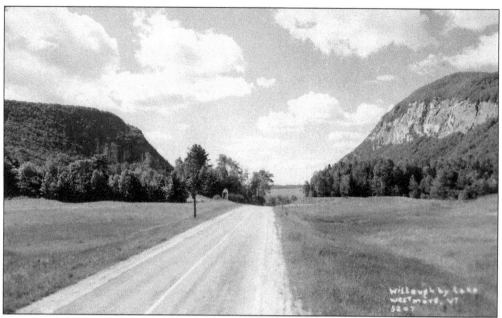

A straight road leads to the heart of Willoughby Lake along the road passing by Mount Pisgah. (Courtesy of Steve Morse.)

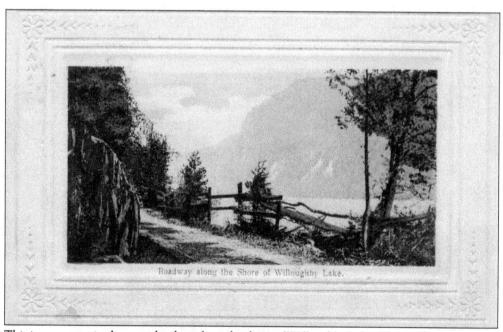

Roadway along the Shore of Willoughby Lake.

This is a very scenic photograph taken along the shore of Willoughby Lake. This card is postmarked Thetford, Vermont, May 30, 1911 and was sent to Mrs. George B. Cummings of Thetford Hills, Vermont, Box 6. It reads, "Dear Mamma, I arrived safely in Windsor Sunday afternoon and Julia met me at the station. We drove down to Sarah's from the station and stayed to tea. Herbert was down there and came back with us. I am well and hope you both are. Be careful, please, Mamma and try not to do too much. I had a nice ride in the auto. Please write as soon as you can. Love, Adelia." (Courtesy of Steve Morse.)

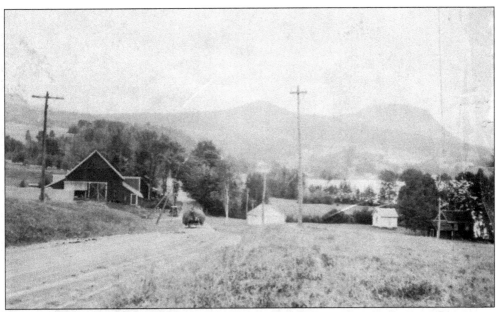

Coming up the road from Willoughby Lake, this farmer carries a wagonload of loose hay from a field to his barn. He passes a few homes and telephone poles on the way. (Author's collection.)

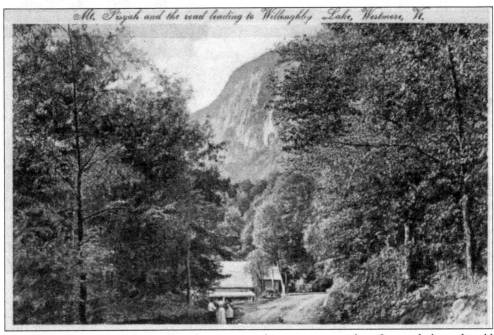

Most of these trees have been cleared away since this picture was taken. Located along the old Route 5A, this road was situated just above the shoreline of the lake that now includes many camps, which are accessed mainly by very steep driveways. A young family strolls on the dirt road enjoying the views. (Courtesy of Steve Morse.)

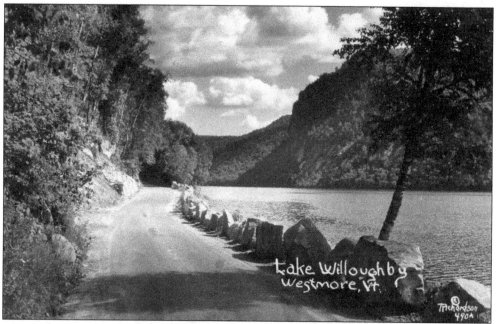

The sharp contrast of black and white is what makes this such an interesting picture. As one passes down the winding road along the lake, it almost looks like he or she will be entering a very dark tunnel. (Courtesy of Kathy Frye.)

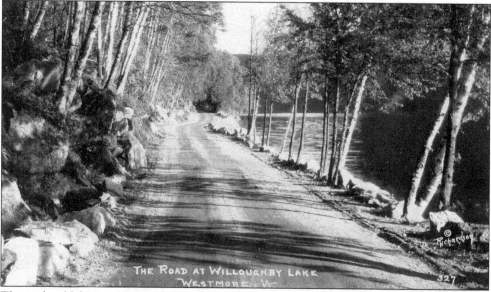

This is the old dirt road before the newer shelf highway was built in 1955. The new road was very difficult to build and involved much manpower and large road equipment. The card was sent to Rachel Bangs, School of Domestic Science, 40 Berkeley Street, Boston, Massachusetts, in 1922. The message written on it says, "Dear Rachel, I left home at 6:10 a.m. and arrived here at 11:40. Travel was 182 miles and took 5 hours. We averaged 33. I drove 53 at one stretch. Fine roads all the way and very little traffic. Very foggy this morning, but fine now. Trees are beautiful and the mountains look good. It seems queer to be away without you and we feel sort of guilty. Hope you are OK. We have had dinner at the same place. Lovingly, Mater." (Courtesy of Kathy Frye.)

Dated December 24, 1914, this card was sent from Westmore, Vermont, to Mrs. T.G. Crandall, Orleans, Vermont. The message states, "Christmas Greetings, Maballe." (Courtesy of Kathy Frye.)

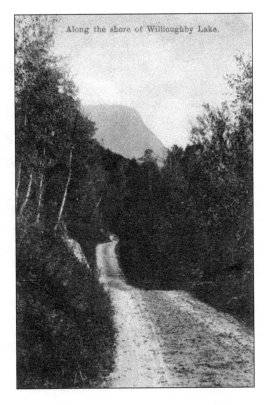

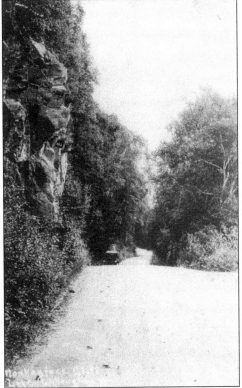

Along the original road by Willoughby Lake once stood a cliff known as Monkeyface Cliff. This picture, taken during the 1920s, shows the profile and why it got its name. When the new road was built, the cliff was sheared off. This was near the location of a natural waterfall, which flows under the road into the lake. (Courtesy of Steve Morse.)

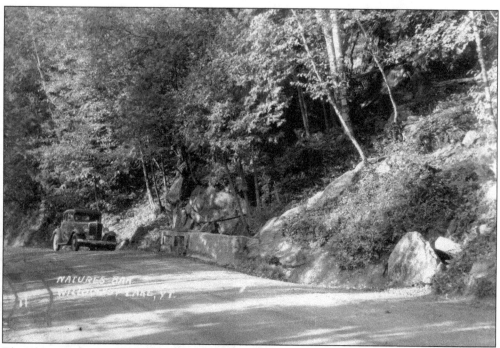

This photograph was taken where a natural waterfall comes down the side of the hill. There now is a nice pullover area where many people stop to enjoy the unobstructed view of the lake and cool off from the spray of the cooling waterfall. This image was captured near the location of where Monkeyface Cliff once was seen. (Courtesy of Ken Barber.)

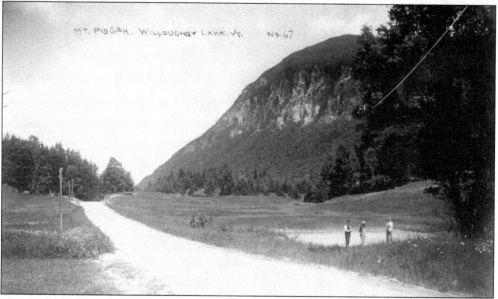

This road heading to Willoughby Lake shows a clear view of Mount Pisgah. There, men stand at the former location of the Lake House Hotel, where many visitors to the area stayed. Located across from the hotel was the Pisgah Lodge, a smaller hotel that housed the overflow from the Lake House. (Courtesy of Ken Barber.)

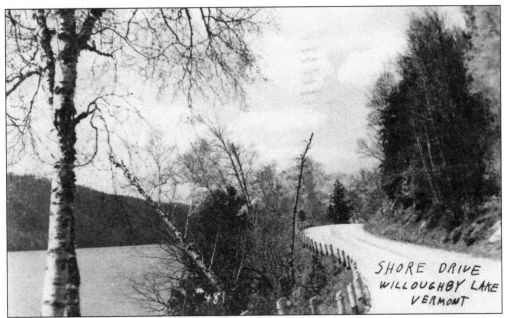

This card, which features an image captured while traveling along Shore Drive on Willoughby Lake, is postmarked Newport, Vermont, July 11, 1952. The message is written in German and was sent to Mr. and Mrs. Hans Wennberg. (Courtesy of Elaine Bandy.)

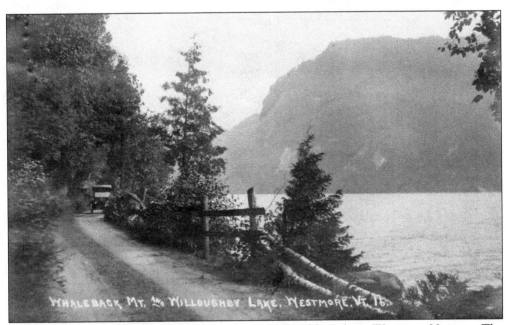

In the background is Whaleback Mountain along Willoughby Lake in Westmore, Vermont. The card is postmarked September 18, 1925, and was sent to Ruth Wilcox at 330 Wadsworth Avenue in New York City. It reads, "I know a real Vermonter will appreciate this view. Hope you haven't forgotten me. Grace S. Carpenter." (Courtesy of Elaine Bandy.)

This old picture of the Willoughby Lake area is undated and was taken long before any camps or hotels grace the roadsides. The forests were very dense and nearly swallow the Cheney House located on the left. Built in 1860 by Robert van Arsdale, the historic Van Arsdale–Cheney House is located on the south end of the lake, just off Route 5A. The property also has a vertical log barn and two-story carriage house. (Courtesy of Kathy Frye.)

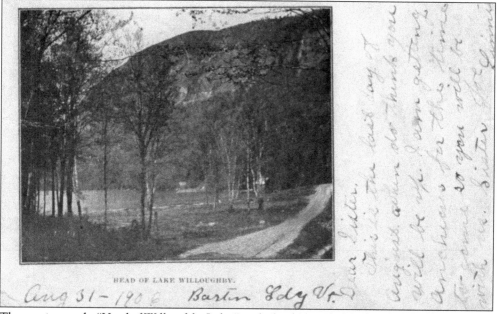

The caption reads, "Head of Willoughby Lake," with the date and place listed as August 31, 1906, Barton Landing (now Orleans), Vermont. The message reads, "Dear Sister, This is the last day of August. When do you think you will be up? I am getting anxious for the time to come so you will be with us, Sister. Joe Linney." (Courtesy of Steve Morse.)

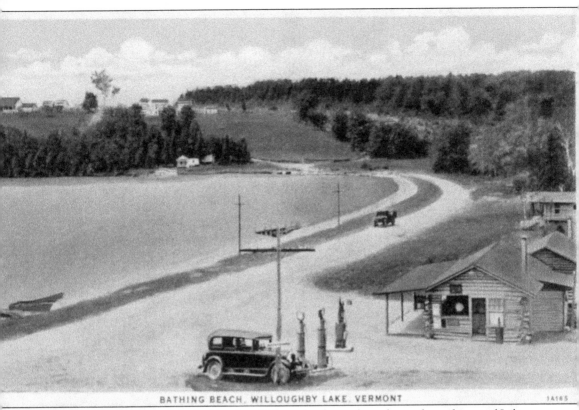

BATHING BEACH, WILLOUGHBY LAKE, VERMONT

This is a great scenic view of the bathing beach along the shore where the road travels around Lake Willoughby. The old gas pumps and car date it to around the 1920s. (Courtesy of Steve Morse.)

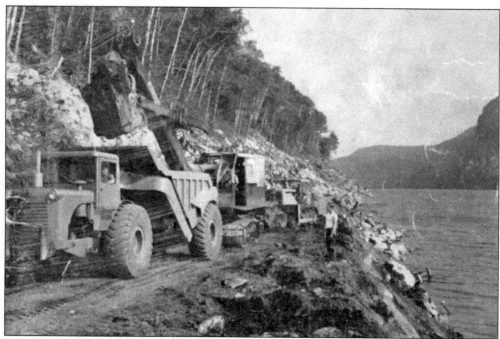

Pictured is the cover of the July 15, 1955, *New England Construction* magazine, which features the building of the shelf highway above Lake Willoughby in 1955. (Courtesy of Associated Construction Publications.)

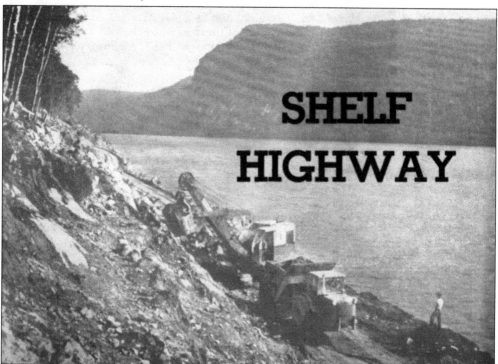

This image shows continuation of the building of the new road along the lake in the July 15, 1955, *New England Construction* magazine. (Courtesy of Associated Construction Publications.)

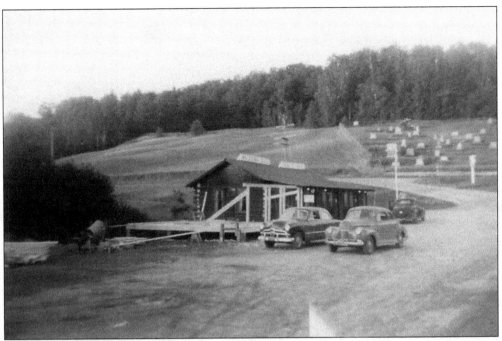

This image of constructing an addition to the Willoughby Lake Cabin Tea Room was photographed by Daisy Sherburne Dopp of Glover. (Courtesy of the Glover Historical Society.)

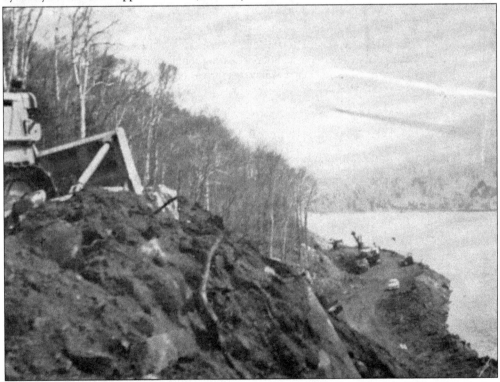

This picture in the *New England Construction* magazine July 15, 1955, issue shows the difficulty in placing the road high above Lake Willoughby. (Courtesy of Associated Construction Publications.)

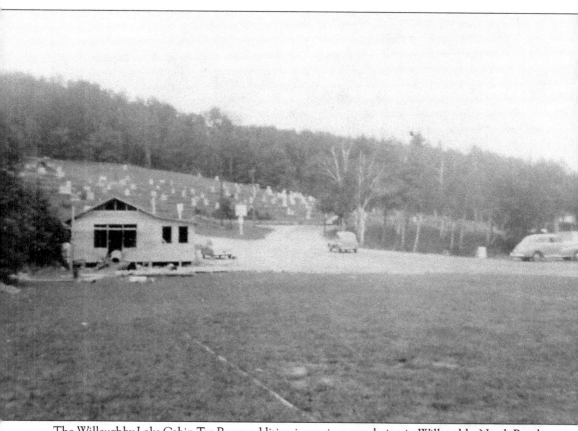

The Willoughby Lake Cabin Tea Room addition is nearing completion in Willoughby North Beach. (Photograph by Daisy Sherburne Dopp of Glover, courtesy of the Glover Historical Society.)

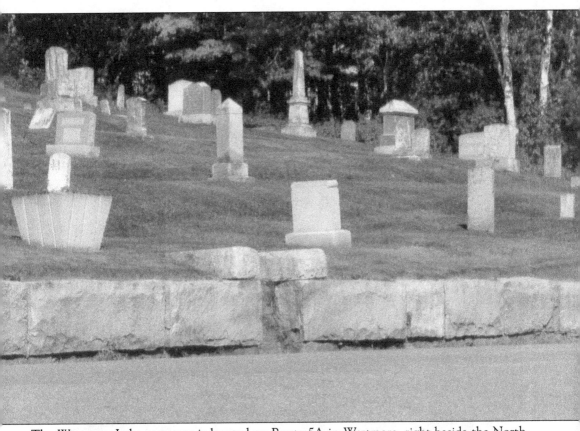

The Westmore Lake cemetery is located on Route 5A in Westmore, right beside the North Beach on Lake Willoughby. The retaining wall surrounding the cemetery was built about 1906. Clinton Orne had a stone quarry on his farm and built the wall with his father, Frank Orne, and grandfather Daniel Orne, according to Marion "Midge" Hunt of Barton, Vermont; the builders were her father, grandfather, and great-grandfather. (Author's collection.)

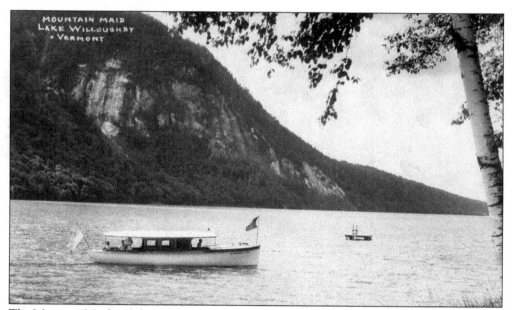

The *Mountain Maid* is gliding along Lake Willoughby on this July day in 1951. The card was sent to Miss Mary Ware in Ashlumhaus, Massachusetts, and the note on the back reads: "Dear Mary: Here in Barton for a few days. Just another view of beautiful Willoughby Lake. Sincerely, C.M. Litch." (Courtesy of Kathy Frye.)

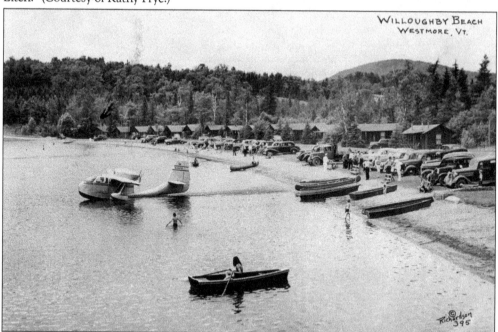

Many families are enjoying a July 1949 day at Willoughby Beach in Westmore, Vermont. Canoeing, swimming, and even an airplane are part of the fun. The note on the back of this card sent to Mrs. William Putnam in Haverhill, New Hampshire, reads: "Sending you a card from the cabins we are staying at and to let you know we heard from Nanny Farman today and she was back at Paula's house by herself and not walking too well but enough to wait on herself. We go home Sunday. Bertha P. Eldred." (Courtesy of Kathy Frye.)

Three

RECREATION AND INDUSTRY ON WILLOUGHBY LAKE

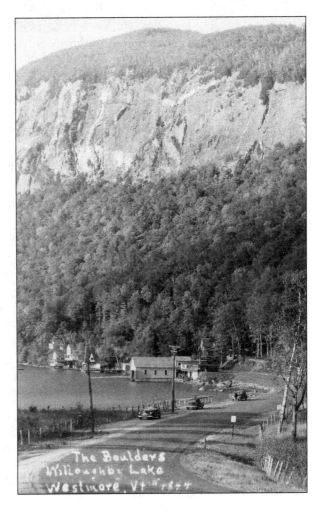

This vertical view shows the Boulders buildings and Mount Pisgah's cliffs, visible in the distance. The letter "S," a natural formation, is noticeable in this photograph. (Courtesy of Steve Morse.)

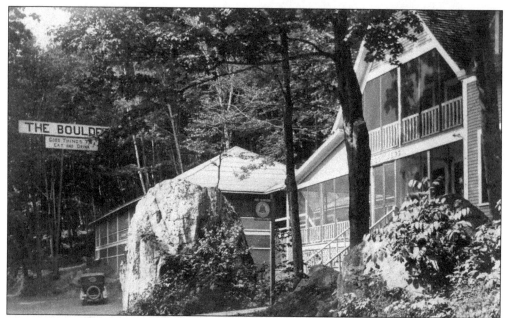

The exterior of the Boulders Restaurant boasts of "good things to eat and drink." The giant boulder announces, "The Boulders," which was painted on it but has long since faded. A Bell Telephone sign hangs outside the adjoining building. This card, postmarked August 1, 1922, was sent to Jane Gage of Ascutneysville, Vermont, care of Prof. J.C. Rogers. It reads, "Dear Jane, We are having ice cream, etc. at this tea shop beside the lake. See the big boulder between the tea shop and dance hall? There are—all about. Love, Aunt [?]." (Courtesy of Steve Morse.)

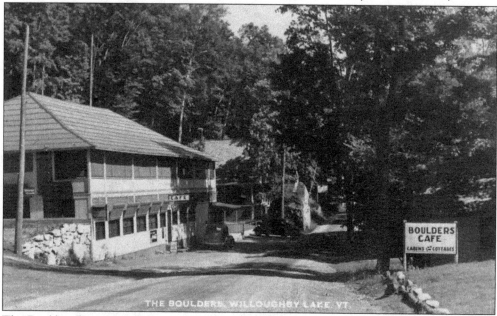

The Boulders Restaurant and Café was a popular destination for locals and visitors from near and far. It was a great spot for good food, good music, and good times with family and friends. Although in disrepair, the building remains standing right beside Route 5A in Westmore. (Courtesy of Kathy Frye.)

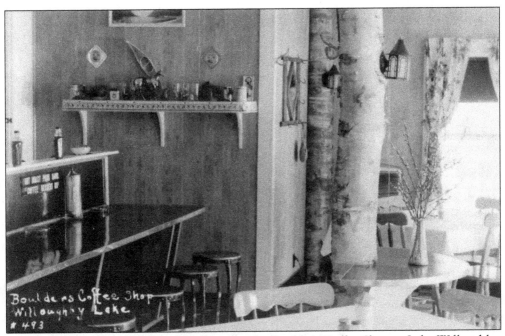

Birch trees were part of the natural décor in the Boulders Coffee Shop at Lake Willoughby. (Author's collection.)

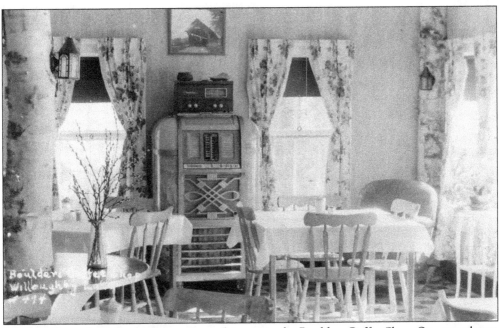

An old radio and jukebox were prominent features in the Boulders Coffee Shop. One can almost hear the music playing from the 1930s and 1940s. (Author's collection.)

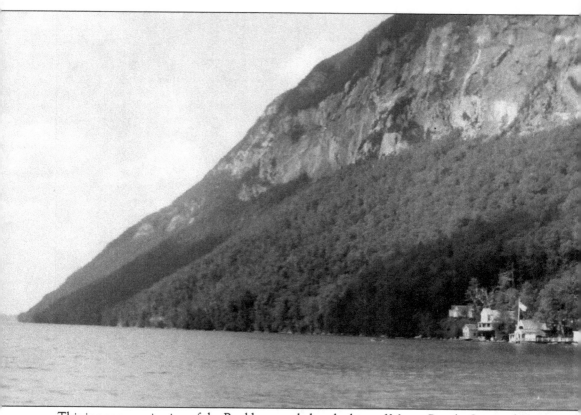

This is a panoramic view of the Boulders, nestled at the base of Mount Pisgah. Once a thriving "hot spot" of activity, it has become fairly quiet since the 1950s. Several camps are lined up on the north side of the lake, and there is no longer a restaurant or coffee shop in this location.

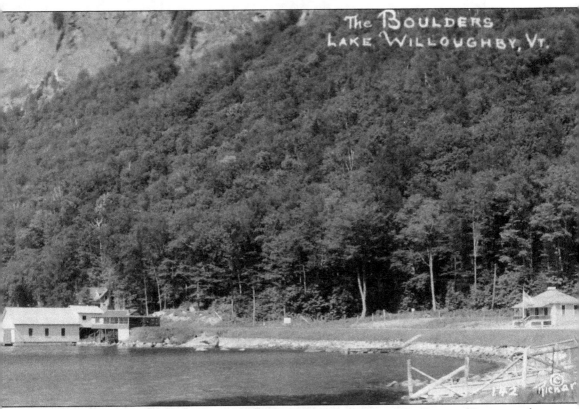

The Boulders was constructed by proprietor and head chef Clarence B. Grapes. (Courtesy of Kathy Frye.)

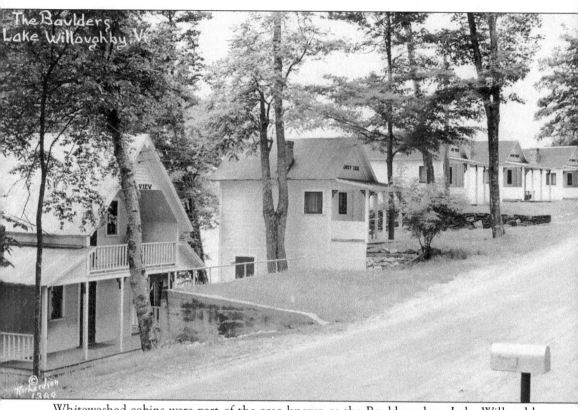

Whitewashed cabins were part of the area known as the Boulders along Lake Willoughby. (Courtesy of Kathy Frye.)

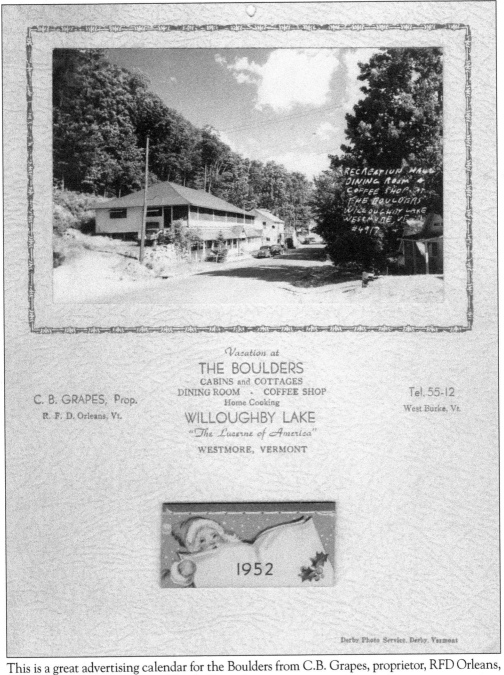

This is a great advertising calendar for the Boulders from C.B. Grapes, proprietor, RFD Orleans, Vermont, in 1952. (Courtesy of Sandy Towns.)

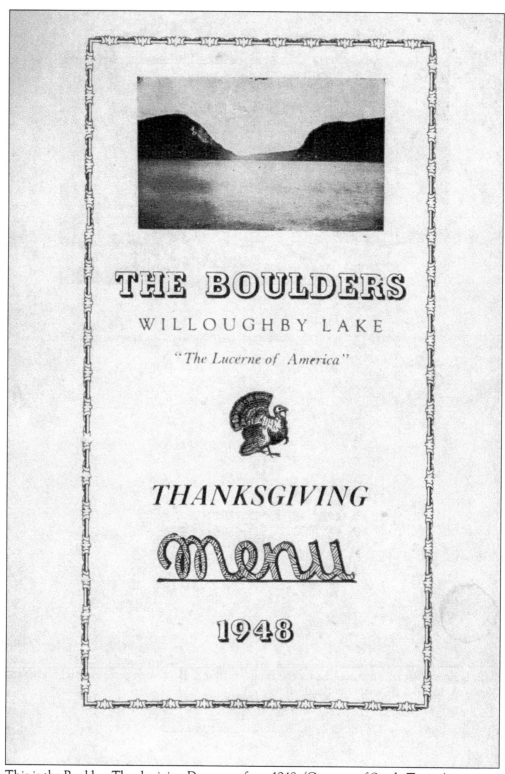

THE BOULDERS

WILLOUGHBY LAKE

"The Lucerne of America"

THANKSGIVING

menu

1948

This is the Boulders Thanksgiving Day menu from 1948. (Courtesy of Sandy Towns.)

MENU

Chilled Apple Juice Cranberry Juice Cocktail

Chicken Broth with Rice

Celery Cluster Raisins Olives

Vermont Oven Roast of Turkey

Giblet Gravy-Boulders Style Dressing $2.50

Oven Baked Virginia Ham

Pineapple-Brown Gravy $2.00

Home Style Chicken Shortcake

Biscuits--Gravy $2.00

Candied Sweet Potato

Baked or Creamed Riced Potato

Buttered Acorn Squash Green Peas in Cream

Creamed Boiled Onions

Assorted Boulders Home Made Rolls

Waldorf Salad Variety Relish Tray

Thanksgiving Steam Pudding

with Ice Cream or Hard Sauce

Pies: Apple - Hot Mince - Cherry - Pumpkin

Sage Cheese American Cheese

Fresh Strawberry Shortcake-Whipped Cream

Ice Cream: Vanilla - Maple Nut - Cherry Flip

Coffee - Tea - Milk - Hot Chocolate

All Food Home Cooked at The Boulders

We thank you and hope you have enjoyed your dinner
You may take this Menu home with you as a Souvenir

Pictured here is the menu featuring the delicious food offerings for this Thanksgiving Day feast. (Courtesy of Sandy Towns.)

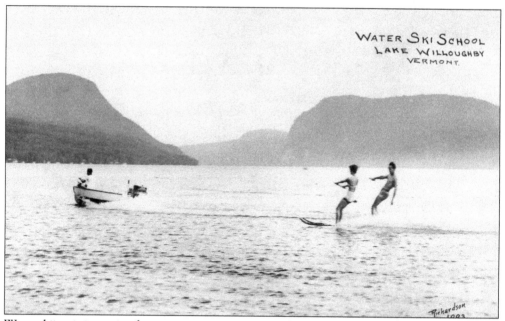

Water-skiing is just one of many activities to enjoy on beautiful Willoughby Lake. (Courtesy of Steve Morse.)

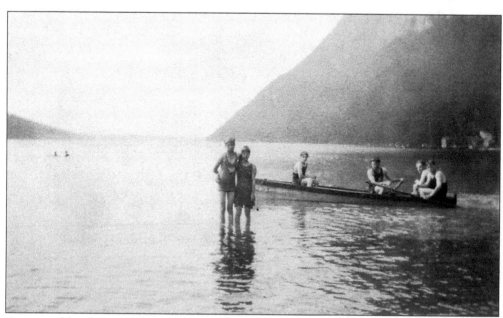

A group of four boys paddles a canoe on placid Lake Willoughby at the base of Mount Pisgah. (Courtesy of Steve Morse.)

A large flock of ducks rests on the lake where melting ice has left some open water. (Author's collection.)

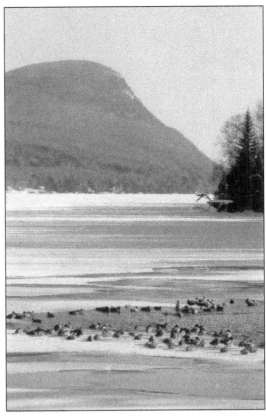

Becky Alexander of Barton and Ken ? relax on the North Beach at Willoughby between their dining-hours chores at the Willoughvale Inn in 1948. (Courtesy of the Wayne Alexander family.)

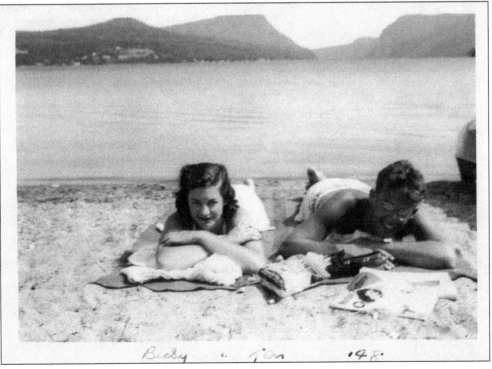

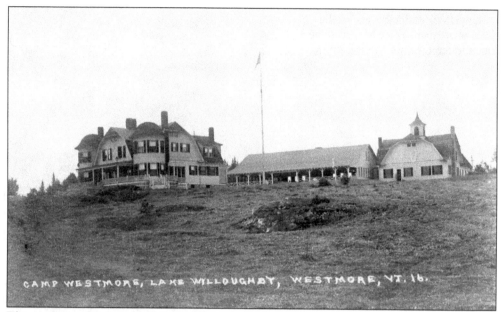

This is a beautiful close-up of Camp Westmore, a popular residence, girls camp, and inn over the years. (Courtesy of Steve Morse.)

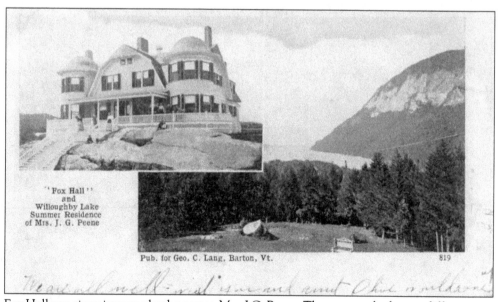

"Fox Hall"
and
Willoughby Lake
Summer Residence
of Mrs. J. G. Peene

Pub. for Geo. C. Lang, Barton, Vt. 819

Fox Hall was given its name by the owner, Mrs. J.G. Peene. The property had many different uses and is still a beautiful building. (Courtesy of Steve Morse.)

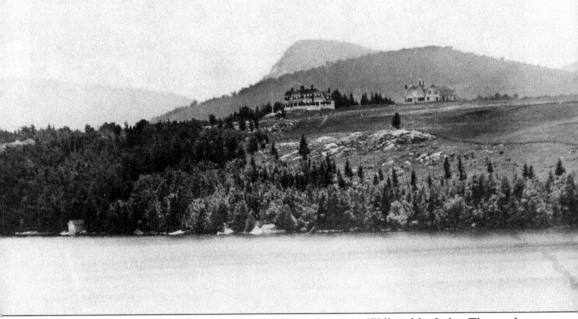

SUMMER HOME OF MRS. PEENE AT WILLOUGHBY LAKE, VT.

High up on a hill is the summer residence of Mrs. Peene at Willoughby Lake. The card is postmarked West Burke, Vermont, on August 18, 1916. It was sent to Mrs. E.C. Dickerman, East Burke, Vermont, and the note on back reads, "Dear Mrs. Dickerman, The bunny's are lovely and so cute. Joyce and I made a house for them under the apple tree behind the house and a little place for them to run about in. I was sorry not to see you when we were over. Wish you would come over sometime. It is not far. Grace I Pond." (Courtesy of Steve Morse.)

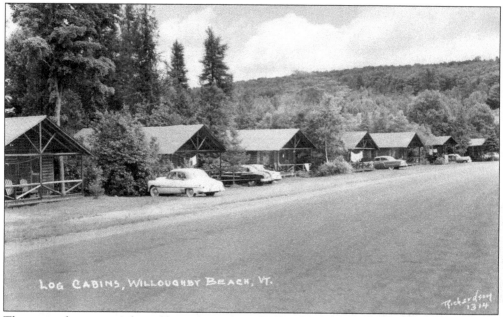

There are always a number of log cabins along Willoughby Beach on the lake. (Courtesy of Elaine Bandy.)

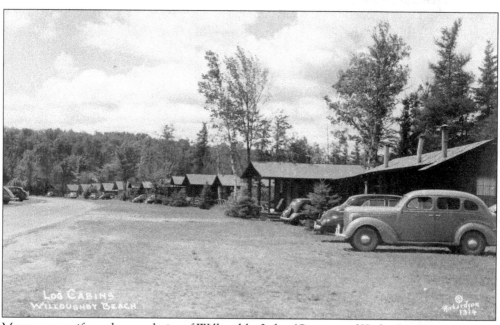

Many cars testify to the popularity of Willoughby Lake. (Courtesy of Kathy Frye.)

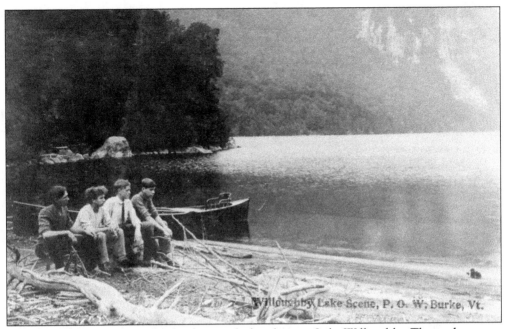

Four young men are waiting by the shore with their boat on Lake Willoughby. The card was sent to Miss Beth Harrington in Eden, Vermont, dated March 11, 1908. The sender simply writes, "Look natural?" (Courtesy of Steve Morse.)

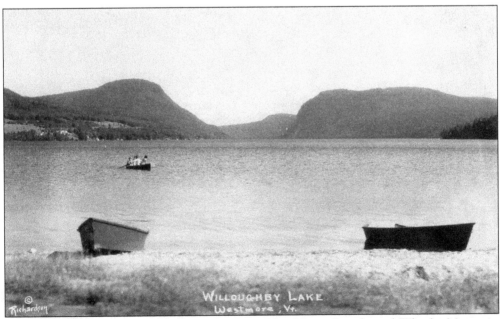

A serene scene is found on the lake with Mount Hor, Mount Pisgah, and Wheeler Mountain framing this boating picture. (Courtesy of Kathy Frye.)

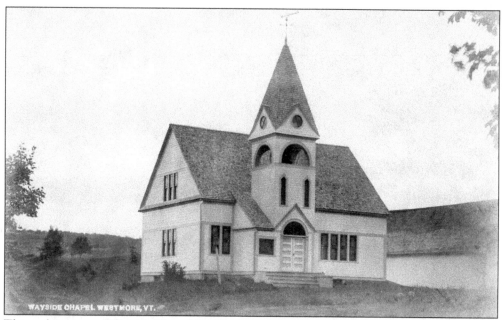

This early picture of Wayside Chapel in Westmore is dated July 1908. A carriage house for horses is to the right of the building. The card was sent to Alice Dashney in West Burke, Vermont. The note on the back reads, "Dance for me as I cannot come. Where are you going to spend your vacation? I have looked for you but that's all the good it's done. Everybody is well and happy here. How is it to be?" (Courtesy of Steve Morse.)

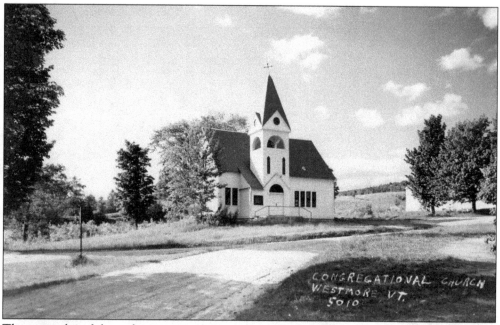

The same chapel from the previous image is seen in this picture, only now it is called the Congregational Church. The community room is to the right of the church. This was probably taken in the 1970s. (Courtesy of Steve Morse.)

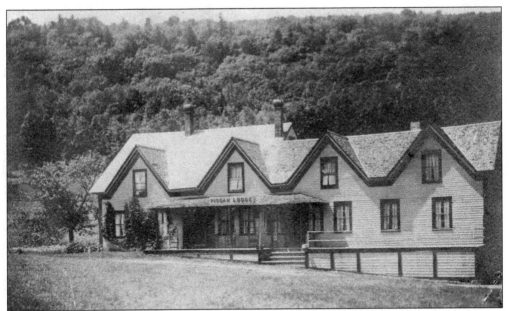

Pisgah Lodge, named for its open view of Mount Pisgah, is awaiting visitors to stay the night in its clean, comfortable rooms. It was located directly across from the Lake House Hotel. The postcard is postmarked August 9, 1917, in West Burke. It was addressed to Mrs. M.B. Eaton of Morrisville, Vermont, and a note reads, "Dear Ma, This is a good picture of the house where we are having a very pleasant time. Shall get to—in a few days. Lovingly, M.M." (Courtesy of Steve Morse.)

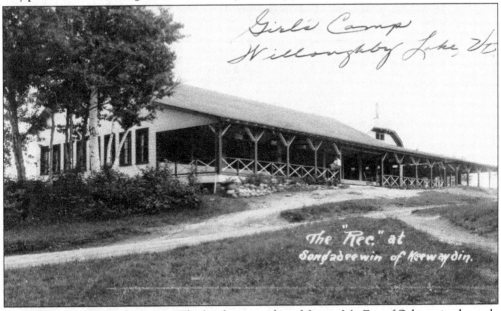

Fox Hall was built by John Peene. The land was purchased from a Mr. Fox of Orleans in the early 1900s. The mansion there was built for Peene's wife, and later sold to Mr. Cookman of Keene, New Hampshire. Many years later, it was sold to the Keewaydin Camp Company. It was renamed Songadeewin of Keewaydin and became quite a popular girls' camp. The name uses American Indian words: *songadeewin* means "gentle wind," and *keewaydin* means "northwest wind." Pictured is the recreation hall at Songadeewin at Willoughby Lake. (Courtesy of Ken Barber.)

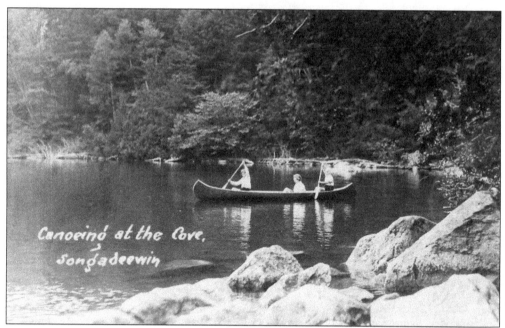

Canoeing at the cove at Camp Songadeewin was great fun for the lucky campers who got to attend this place. The card is postmarked at Barton, Vermont, on August 6, 1931, and was sent to Reed Clayton at 4023 School Lane in Drexel Field, Pennsylvania. It reads, "Dear Bunny, I've been hearing that you are quite peeved at me. Well, how would you like to take a ride in a canoe like this? Love, Gingue." (Courtesy of Steve Morse.)

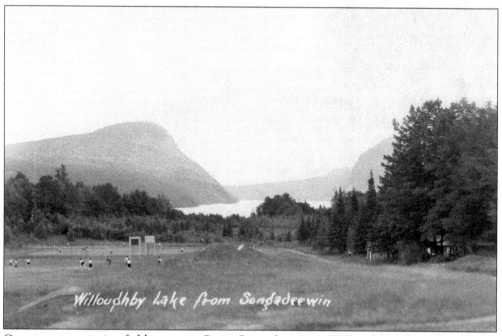

Campers are enjoying field sports at Camp Songadeewin at Willoughby Lake. (Courtesy of Ken Barber.)

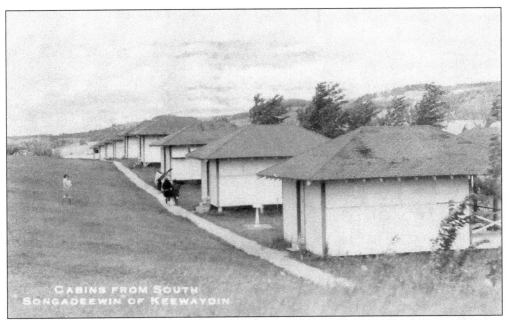

These cabins are at Songadeewin of Keewaydin. This card was also sent to Reed Clayton and the handwritten note reads, "Dear Reed, This is where I used to sleep before this year. They didn't have any picture of senior cabins. Write to me. Love, Marion." (Courtesy of Steve Morse.)

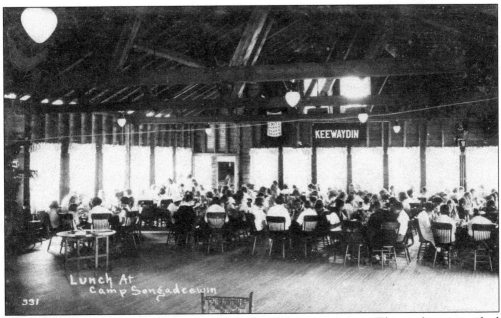

The lunchroom at Camp Songadeewin is packed with hungry campers. This card is postmarked at Barton, Vermont, on August 15, 1930, and was sent to Reed Clayton; the back reads, "Dear Bunnie, This is where we eat all our meals. Received your card the other day and I will try to bring it home. Love, Gingue." (Courtesy of Steve Morse.)

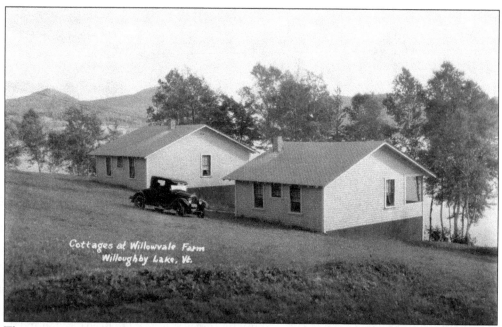

These are great views of cottages at Willoughvale Farm along Willoughby Lake around the 1930s. (Courtesy of Ken Barber.)

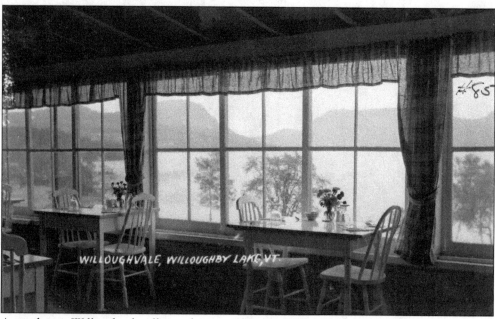

A window at Willoughvale offers a glimpse of beautiful Lake Willoughby, and Mount Hor and Mount Pisgah watch over the scene. (Courtesy of Ken Barber.)

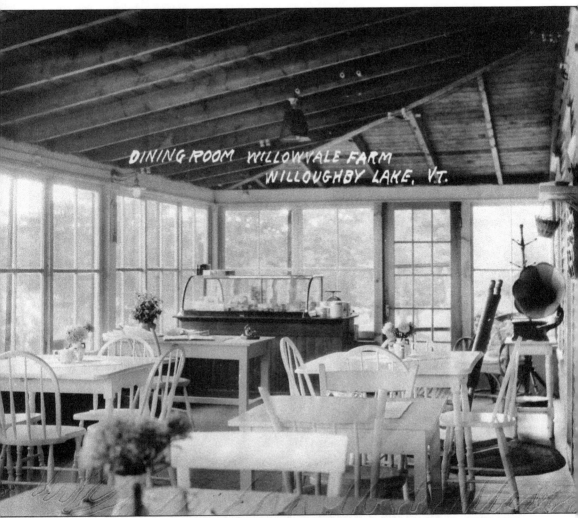

This is an overall view of the Dining Room at Willoughvale Farm restaurant by Lake Willoughby. Notice the old gramophone on the right. (Courtesy of Ken Barber.)

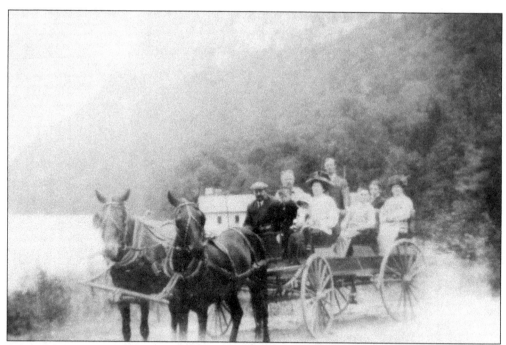

A horse-drawn wagon carries men, women, and children along the old dirt road beside Willoughby Lake, with Mount Pisgah barely visible in the background. (Author's collection.)

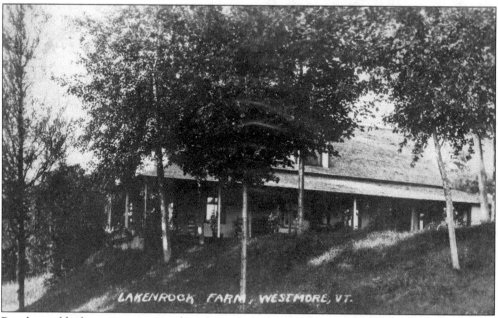

LAKENROCK FARM, WESTMORE, VT.

People would often give names to their farms. Lakenrock Farm in Westmore is what the owners named this farm. This card is dated December 27 and was sent to Mrs. Fred Grendin in Barton. A handwritten note on the back reads, "Best wishes for the New Year for you and yours. Sincerely, Alma S. Craig." Before greeting cards came into fashion, it was customary to send postcards at holidays and for special occasions. (Courtesy of Kathy Frye.)

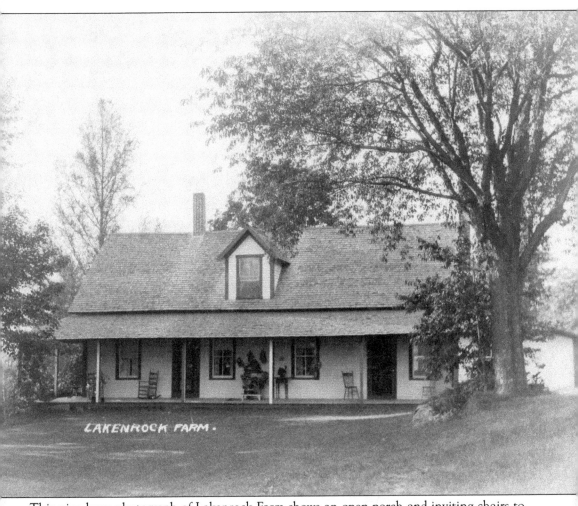

This nice large photograph of Lakenrock Farm shows an open porch and inviting chairs to welcome the weary traveler. (Courtesy of Ken Barber.)

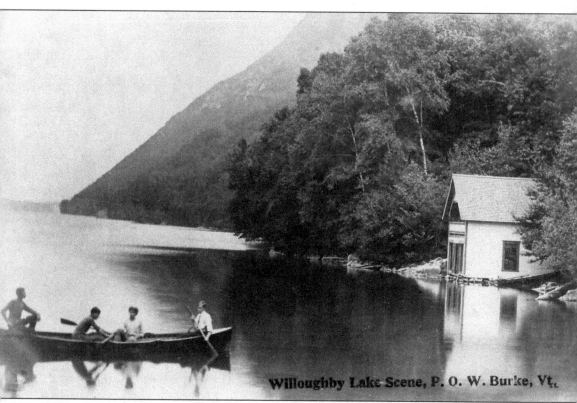

Willoughby Lake Scene, P. O. W. Burke, Vt.

Four boys paddle their canoe in the shallow waters of Willoughby Lake. (Courtesy of Steve Morse.)

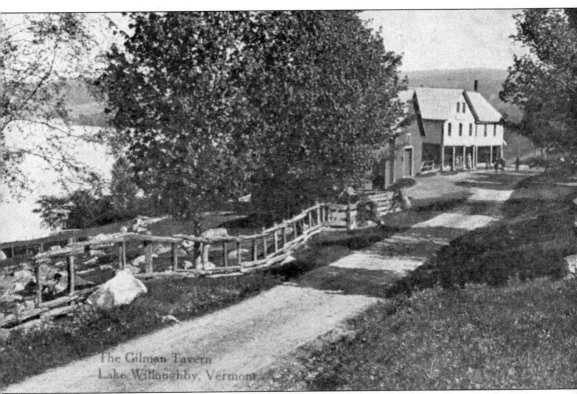

The Gilman Tavern
Lake Willoughby, Vermont

The Gilman Tavern is pictured here in an old postcard that reads, "Dear one and all. Why don't you come up? Seems a long time to wait for mama who wants to see you. All's well. Stay safe at home and at work and tell Earl to write to his mother. Write soon. Love from Mama." Peter Gilman was born in 1796 in Gilmantown, New Hampshire, and became acquainted with Westmore when he did some surveying with George Chandler, who owned large tracts of land there. In 1832, Gilman moved his family to the wilderness south of Willoughby Lake. He kept a tavern in his new house; much of his winter business was from teamsters who came across the ice from Canada. In 1839, he moved nearer the lake, then a wilderness. He first built a log house on the lakeshore; then, about 1850, he built a frame house. Sometime in this period, he put up the building that became known as Gilman's Tavern. Because Gilman had used his own funds to finish the east shore road and had never been reimbursed, he was poor when he died in 1872. (Courtesy of Steve Morse.)

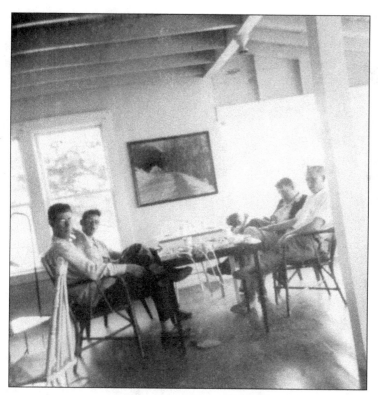

This c. 1948 picture was taken inside the Willoughby Lake Cabin Tea Room. From left to right are Rollie Strong, Wayne Alexander, an unidentified child, Warren Alexander, and Richard "Jake" Jacobson. Wayne and Warren were brothers who grew up in Glover and Barton; Rollie was the husband of the Alexanders' sister Rebecca "Becky," and Jake was the husband of their sister Eleanor. (Courtesy of the Wayne Alexander family.)

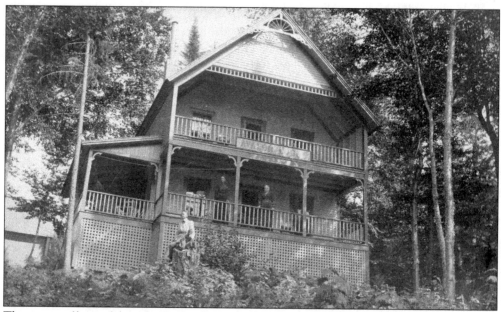

This image of beautiful Avalon Lodge features two ladies in dark dresses on the porch and a lady with a white blouse. (Courtesy of Greg Gallagher.)

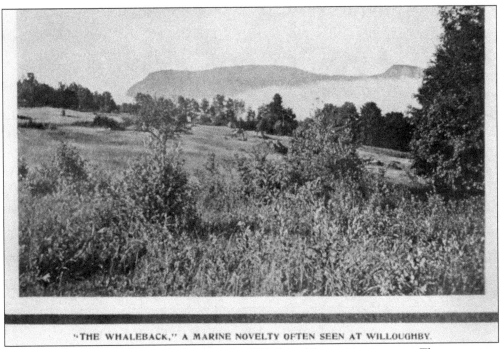

Because of the shape visible on the horizon, the "Whaleback" was given its name. There are many different shapes and figures along the mountain backgrounds around Lake Willoughby. This image is from a 1912 issue of the *Vermonter* magazine. (Courtesy of the *Vermonter* magazine.)

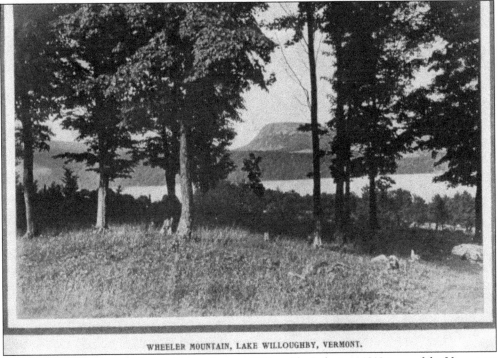

Wheeler Mountain is seen between trees here at Willoughby Lake in a 1912 issue of the *Vermonter* magazine. (Courtesy of the *Vermonter* magazine.)

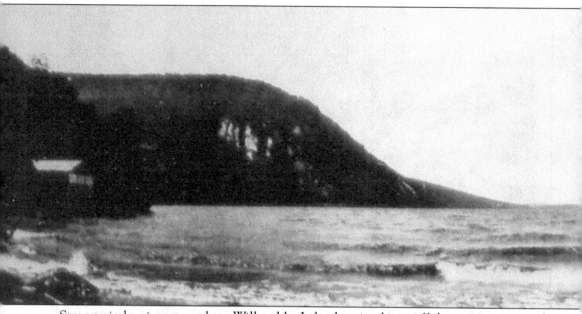

Strong winds raise waves along Willoughby Lake, keeping boats off the water temporarily.

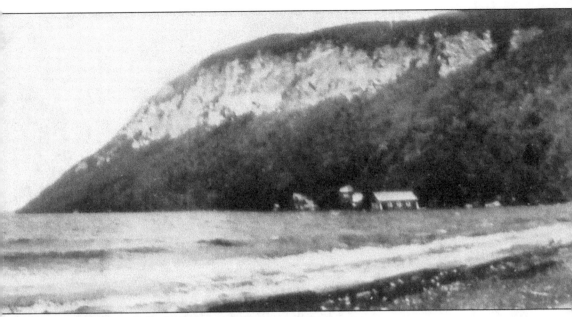

(Courtesy of Greg Gallagher.)

Corn Roast Willoughby Lake.

This is an advertising page from *Automobile Green Book* that features Doring's Inn and Cottages; it is probably from the 1920s. (Courtesy of Greg Gallagher.)

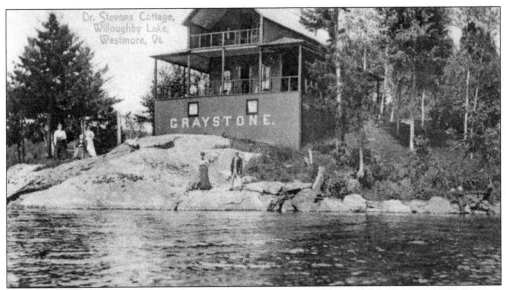

Foster's Grove is the name given to a group of cottages in Westmore. One of the oldest cottages in this grove is the Graystone, built in 1900 by John Howland, then president of Vermont Life Company. This early postcard was sent to Frank A. Morse, Bakersfield, Vermont, and a note on the back reads, "Will just drop you this card tonight and let you know I am well and write more when I receive yours. Have just written Alice D.—Elsie stayed with me and is here still. How nice and warm it keeps. It is awful smoky here today. My tooth is badly inflamed and quite sore but I shall have to have the filling out. C." (Courtesy of Steve Morse.)

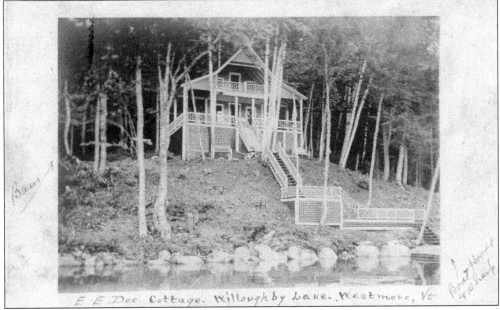

A picture shows the E.E. Doe cottage, which was located just above Willoughby Lake. The card is dated August 3, 1907, and postmarked Barton Landing (now Orleans). It was sent to W.M. Allis in Northampton, Massachusetts, and reads, "Friend Bill, Here is where we catch five pound salmon and trout. I never expect to see you, but if you came up, I will try and give you a good time. Love friend, E.E. Doe." (Courtesy of Elaine Bandy.)

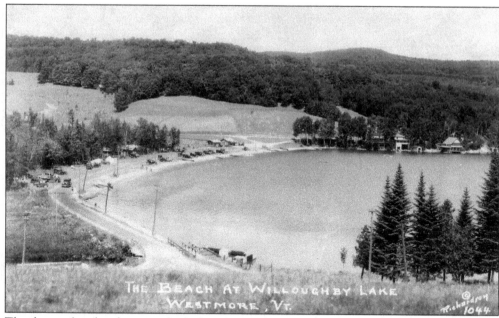

The shore is lined with cars and telephone poles along the beach. This card was postmarked in Orleans on August 1, 1938, and was sent to Mr. and Mrs. Royal ? in Avon, Connecticut. A note on the back reads, "We are having fine weather here. Hope it stays this way. May and Frank." (Courtesy of Steve Morse.)

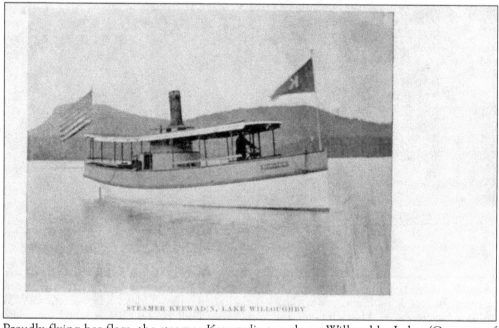

Proudly flying her flags, the steamer *Keewaydin* travels on Willoughby Lake. (Courtesy of Steve Morse.)

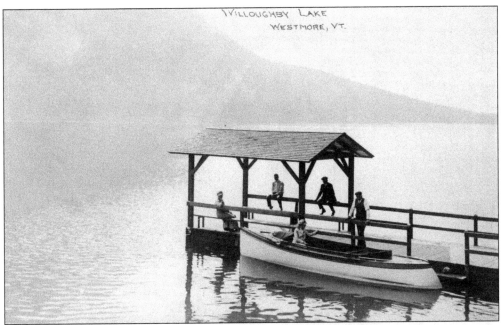

Four men pose on the boat dock while a lady waits patiently for a ride around the lake. (Courtesy of Elaine Bandy.)

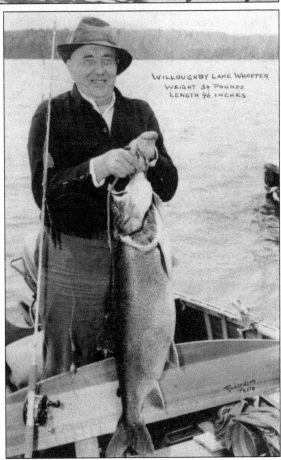

In May 1960, Leon Hopkins is the proud fisherman who has caught this huge 46-inch-long fish weighing 34 pounds. Many trout and salmon grew to great size in the cold, clear waters of Lake Willoughby. The card was postmarked in Derby Line, Vermont, on July 11, 1962. It was sent to Fred Kidder, who lived on Kidder Road in Bradford, Vermont. The message reads, "Hi Fred, How would you like to catch one like this? I went over to Lake Seymour last night—ate supper at Jerry Bailey's and went for a motorboat ride on the lake. Sure was fun—see you Saturday. Love, Kent." (Courtesy of Kathy Frye.)

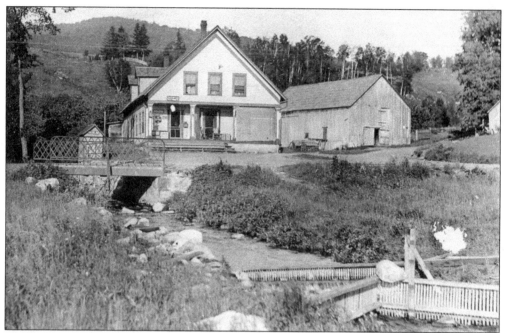

This is a very scenic photograph of the Westmore Store, which also included the post office. An old wagon sits between the store and an old barn. The building is now the Willoughby Lake Store. (Courtesy of Ken Barber.)

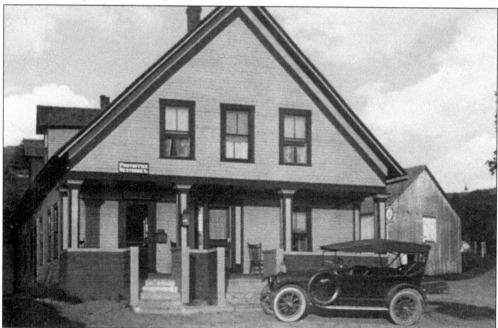

This was the Westmore Post Office in 1920. The building became Millbrook Store and, in recent years, the Willoughby Lake Store. Being the only store in the area, the place is quite busy. Like those of many businesses today, the owners diversified what they carry. They have souvenirs, postcards, and a full-service deli with delicious food. Wilmer Daniels once ran the store, and his brother Percival was the town clerk. (Courtesy of Jim Towns.)

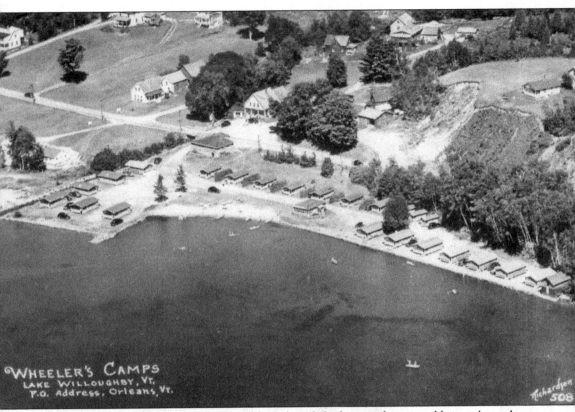

WHEELER'S CAMPS
LAKE WILLOUGHBY, VT.
P.O. Address, Orleans, VT.

Richardson
508

Wheeler's Camps line the beach at Willoughby Lake, while the gravel pit is visible just above the cabins. The early sawmill is situated in the center at the top of the view, while the store is below that and to the left. (Courtesy of Steve Morse.)

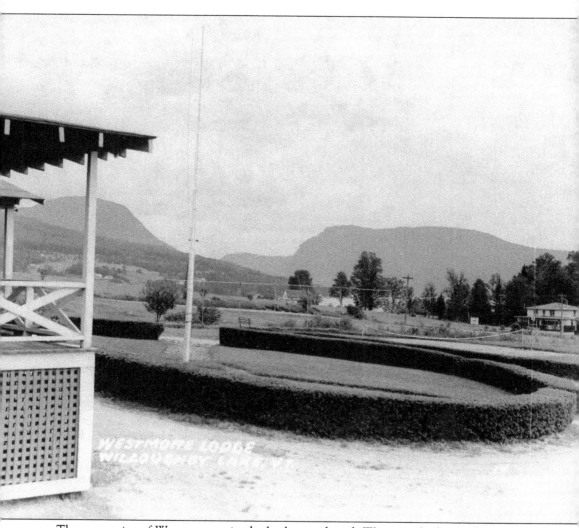

The mountains of Westmore are in the background, with Westmore Lodge in the foreground. Several homes and the lake are just visible in the background. (Courtesy of Ken Barber.)

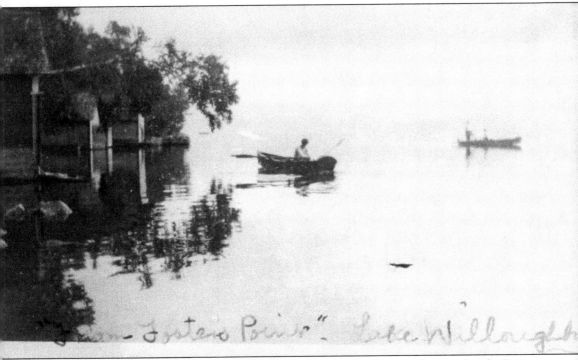

Labeled "'From Foster's Point'—Lake Willoughby," this c. 1918 photograph was taken by Daisy Sherburne of Glover. (Courtesy of the Glover Historical Society.)

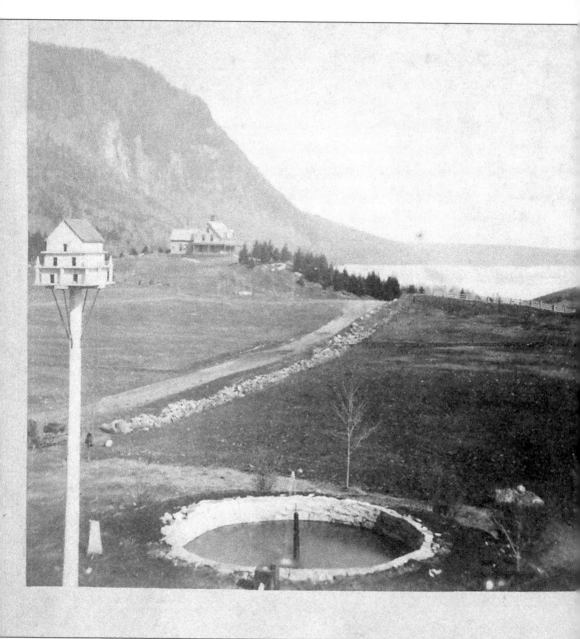

Probably taken from the Lake House Hotel, these stereoscopic pictures show the Cheney House

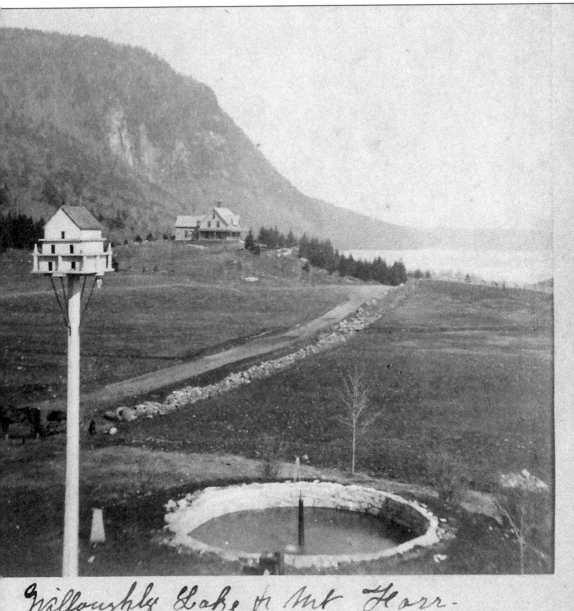

Willoughby Lake & Mt Horr.

situated above Willoughby Lake; Mount Hor is in the background. (Courtesy of Steve Morse.)

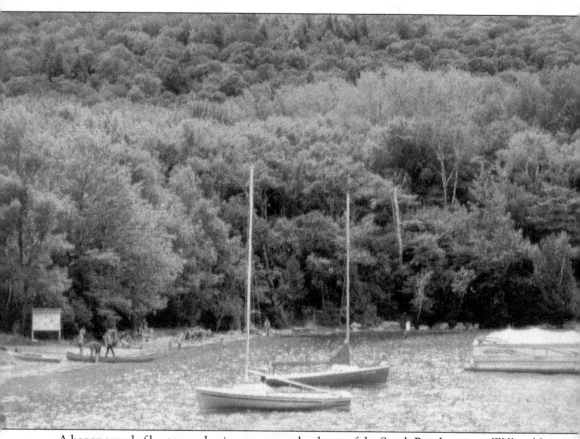

A happy crowd of boaters and swimmers grace the shores of the South Beach cove on Willoughby Lake. The luscious green forests in the background are part of many such areas in Vermont, which is the source of the name given to the mountains in the Green Mountain State. (Author's collection.)

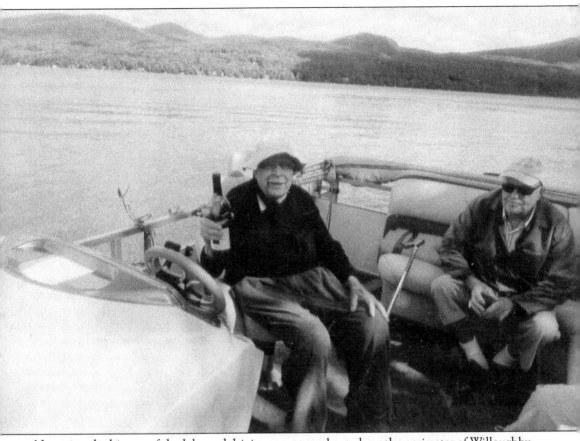

Narrating the history of the lake and driving a pontoon boat along the perimeter of Willoughby Lake, Steve Tanner (left), known as "Uncle Steve," conducts an interesting ride for a small group. Pictured with Tanner is Jim Chamberlain of Barton. (Author's collection.)

These well-maintained cottages have lined the shores of Willoughby Lake for many years. Seasonal visitors can still rent Wheeler's Cabins today. (Author's collection.)

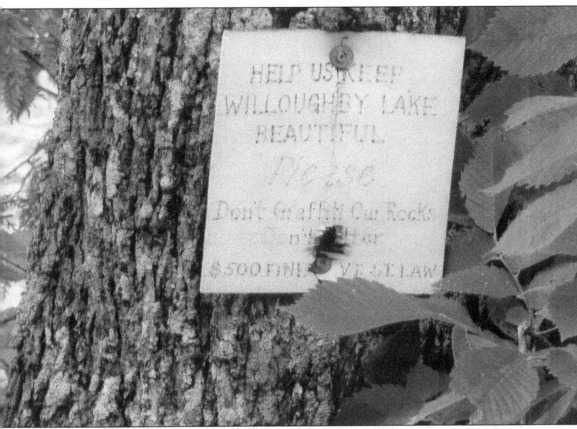

This sign nailed to a tree along Vermont Route 5A in Westmore is showing its age. It states, "Help Us Keep Willoughby Lake Beautiful. Please Don't Graffiti Our Rocks. Don't Litter. $500 Fine. Vt. St. Law." (Author's collection.)

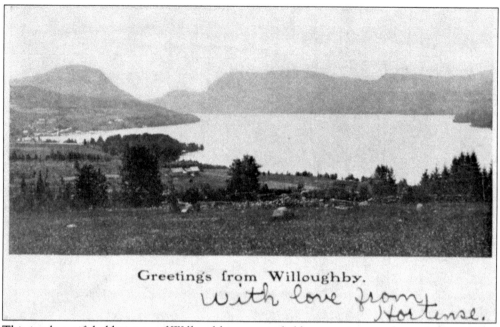

Greetings from Willoughby.

With love from Hortense.

This is a beautiful old picture of Willoughby, surrounded by many trees and very few buildings, and its mountains. The card has a Westmore postmark from July 14, 1905. It was sent to Alice Dashney in West Burke, Vermont. (Courtesy of Steve Morse.)

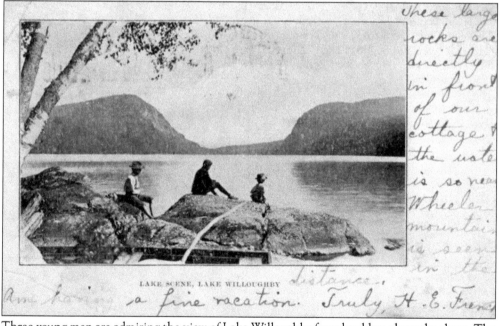

LAKE SCENE, LAKE WILLOUGHBY

These large rocks are directly in front of our cottage & the water is so near Wheeler mountain is seen in the distance. Am having a fine vacation. Truly, H. E. Fren...

Three young men are admiring the view of Lake Willoughby from boulders along the shore. The card is written to Alvah Bellrose of Lowell, Vermont, and postmarked August 13, 1912. It reads, "Hello Everyone. How are you making it? We are having a grand time. How would you like to be fishing like these men? How is Gramp? Chloe." (Courtesy of Steve Morse.)

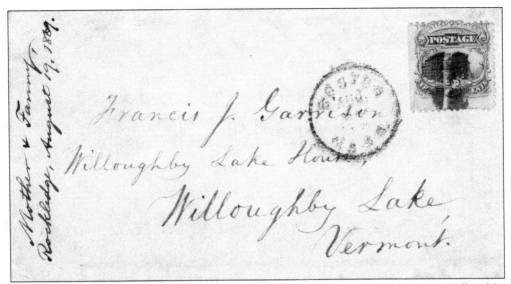

Here is a small envelope addressed to Francis J. Garrison, Willoughby Lake House, Willoughby Lake, Vermont, from Boston, Massachusetts; it was from "Mother and Fanny, Rockledge, August 19, 1869." Notice the lovely penmanship. (Courtesy of Steve Morse.)

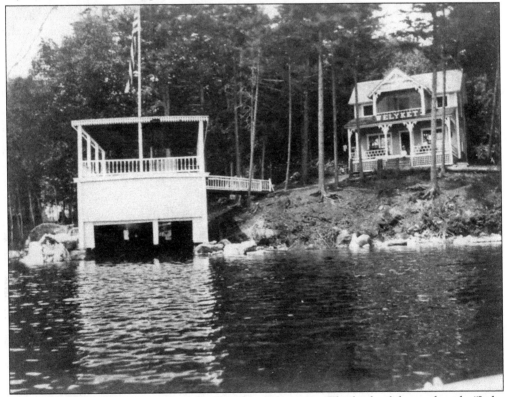

Someone owned this fancy cottage and boathouse long ago. The back of the card reads, "Lake Willoughby, Vermont. Vacation home of Lester Bill on Lake Willoughby, Vermont. The camp is named 'Welyket' (i.e. 'We like it!') Mr. Bill was a close friend of Thomas Edison." (Courtesy of Steve Morse.)

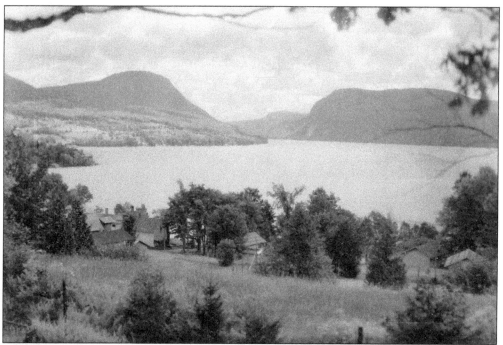

A cloudy day does not dim the beauty of a place such as Lake Willoughby. A few camps in the foreground are surrounded by many shade trees. (Courtesy of Ken Barber.)

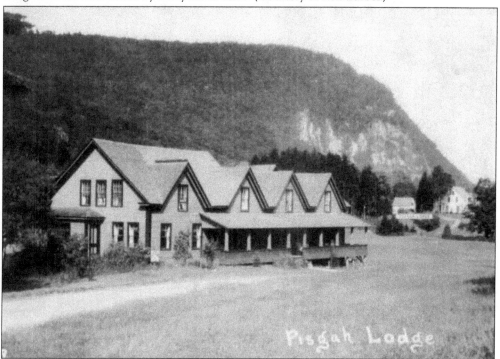

Looking like an old rambling farmhouse (which it was at one time), Pisgah Lodge once stood across from the Willoughby Lake House. The lengthy foundation is still partially there today. (Courtesy of Steve Morse.)

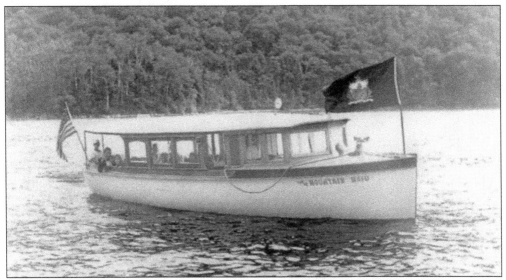

The *Mountain Maid* travels at the base of steep Mount Pisgah on this beautiful summer day. Originally called the *Burklyn*, it was designed by Elmer Darling. It was named for his mansion located on the Burke-Lyndon town line near East Burke. This motor launch was built for Darling in 1910 in Canton, Ohio, and shipped to a local station by rail and then by horses to Willoughby Lake. This was a 35-foot cruiser made of oak and mahogany, with brass fittings and cupboards featuring etched-glass doors. When David Grapes Jr. purchased the Darling property, the sale included this launch. This image is from Harriet F. Fisher's 1988 publication *Willoughby Lake Legends and Legacies*. (Courtesy of Steve Morse and the Orleans County Historical Society.)

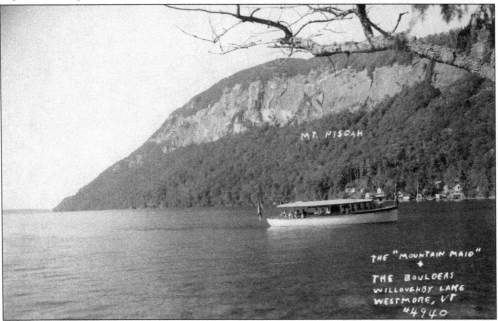

The *Mountain Maid* traveled around Willoughby Lake, providing visitors with the history and grandeur of Westmore. It is reported that in 1975, the *Mountain Maid* (in very poor condition) was moved to the Shelburne Shipyard in Shelburne, Vermont, in hopes of having it restored for use on Lake Champlain. It is perhaps still in that area. (Courtesy of Steve Morse.)

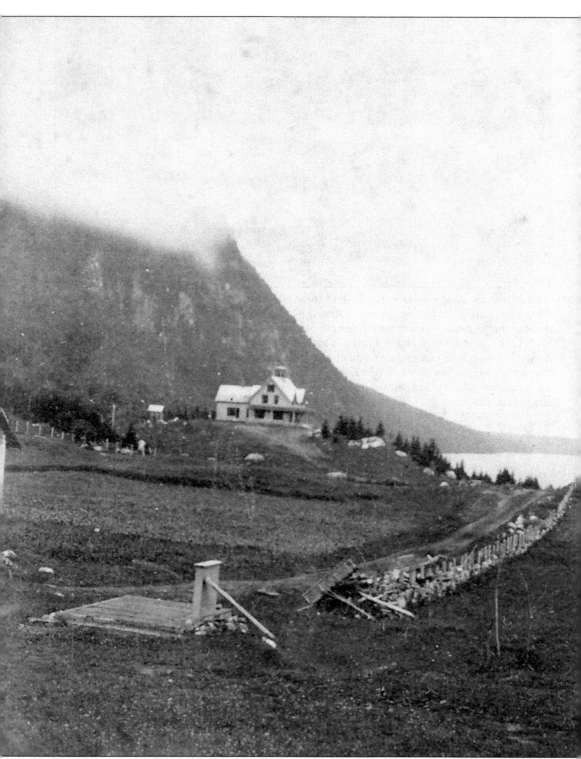

Vermont, being the rocky state that it is, is often depicted with many fences made of rocks and stones gathered from its many fields. This road, located below the Cheney House, is a fine example.

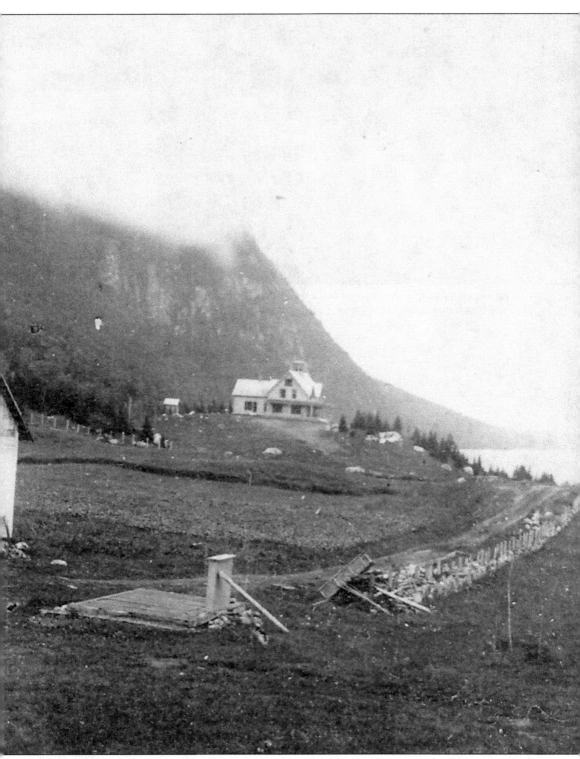

This stereoscopic view was taken in the late 1800s. The Cheney House was the first cottage built along the lake. (Courtesy of Steve Morse.)

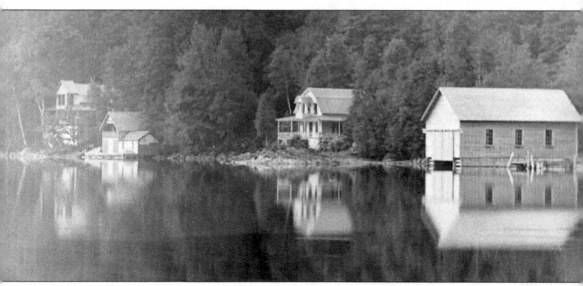

Cottages along the lake were owned by Franklin H. Orcutt, Fred T. Porter, and Mrs. N.N. Coe, and the boathouse belonged to Elmer Darling. (Courtesy of Steve Morse.)

All that remains of the Peter Gilman Tavern is the lengthy rock foundation, which is just over a grassy bank at the very beginning of the old Route 5A road. (Author's collection.)

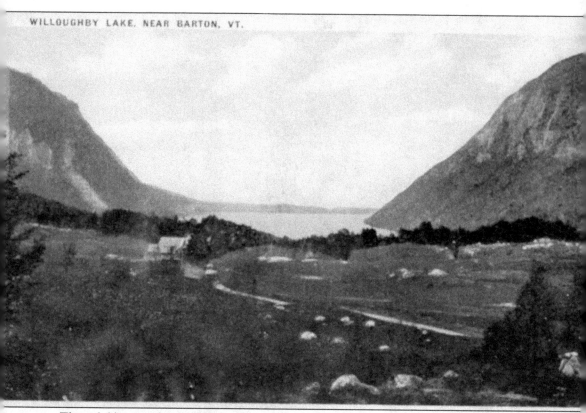

These fields around Lake Willoughby are abundantly overflowing with many rocks and stones, which possibly contributed to the foundations of hotels and cottages in the area around the lake. (Author's collection.)

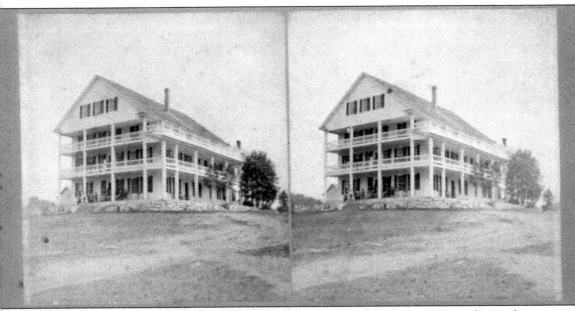

This beautiful stereograph of Willoughby Lake House shows a few of its visitors on the porches and the well-made rock foundation, which still partially stands. (Courtesy of Steve Morse.)

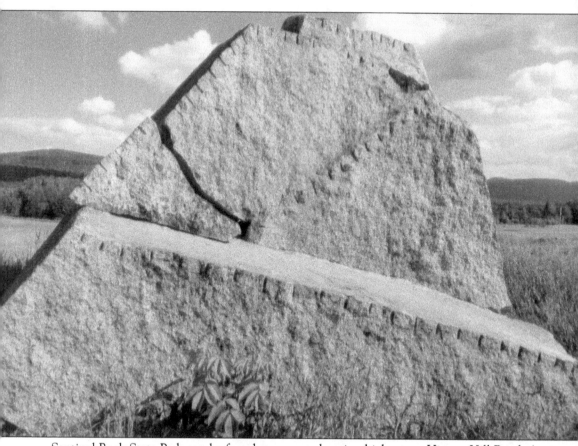

Sentinel Rock State Park can be found at a great elevation high up on Hinton Hill Road. An unsurpassed view from there leaves observers speechless. John and Inez McLaughlin built the farmhouse and barn during the 1890s. The farm's rocky soil was the source of the foundation stones for the buildings. They continued farming until John's death in 1921. Inez farmed for another 10 years and even bought an additional 142 acres. (Author's collection.)

In 1931, Inez McLaughlin sold the property to Clarence Magill, her hired hand of 10 years. Clarence gave up farming in 1944 and moved to Newport, Vermont. The farm was vacant until Charles L. Wright Sr. of Longmeadow, Massachusetts, bought it in 1947. The Wright family owned the property for 50 years, donating it to the State of Vermont in 1997. Now, everyone can enjoy this gorgeous site. (Author's collection.)

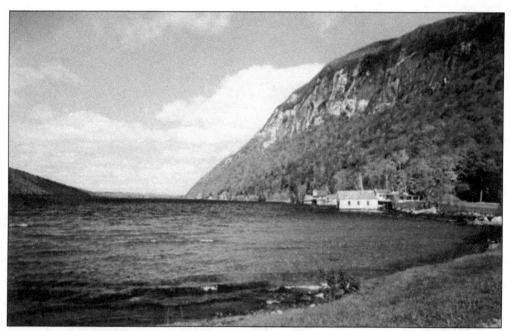

Autumn colors spill down the steep slopes of Mount Pisgah to the ice-cold waters below. (Author's collection.)

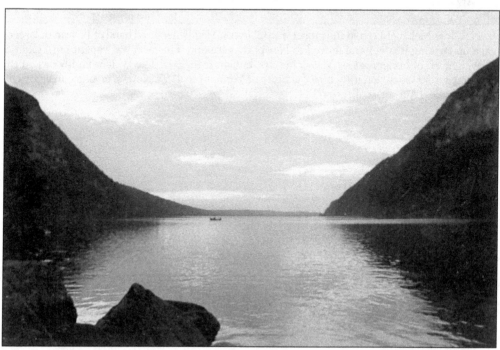

Lake Willoughby and the cliffs of Mount Hor and Mount Pisgah compose a scenic setting of majestic beauty as a lonely boat enjoys the setting sun. (Author's collection.)

A souvenir ribbon is from a Field Day on August 14, 1909, and was sponsored by the Willoughby Fish and Game Club. (Courtesy of Steve Morse.)

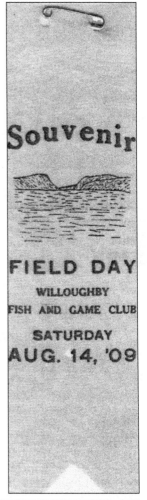

A large crowd of men and women, most of them wearing hats, gather on a rainy day on the shores of Lake Willoughby around 1910. (Courtesy of Steve Morse.)

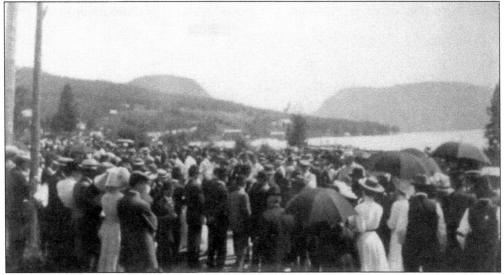

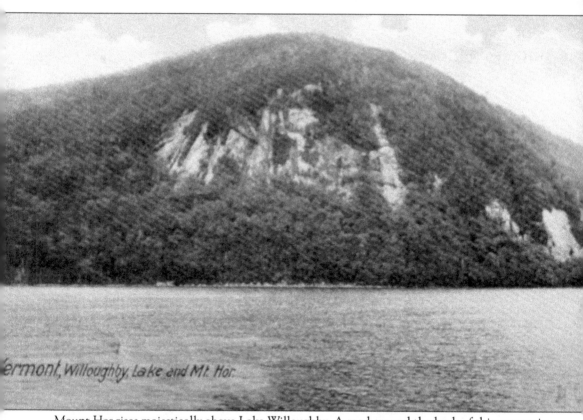

ermont, Willoughby, Lake and Mt. Hor.

Mount Hor rises majestically above Lake Willoughby. A road around the back of this mountain offers a great view of the lake and Mount Pisgah. There is a convenient area beside the road where one can enjoy the overall beauty of the area. During Prohibition, a few enterprising young men brewed moonshine in a remote cave in the side of this mountain. "Moonshiner's Cave," as it was named, was discovered by the authorities and shut down. Nancy Tanner of Westmore and her family had picnics in the cave. Paul LeBrecque told how his father, Henry, had removed the cornmeal that was left in the cave. Henry fed the cornmeal to his chickens, making them a bit tipsy. Paul said it "was the funniest thing he ever saw." (Courtesy of Elaine Bandy.)

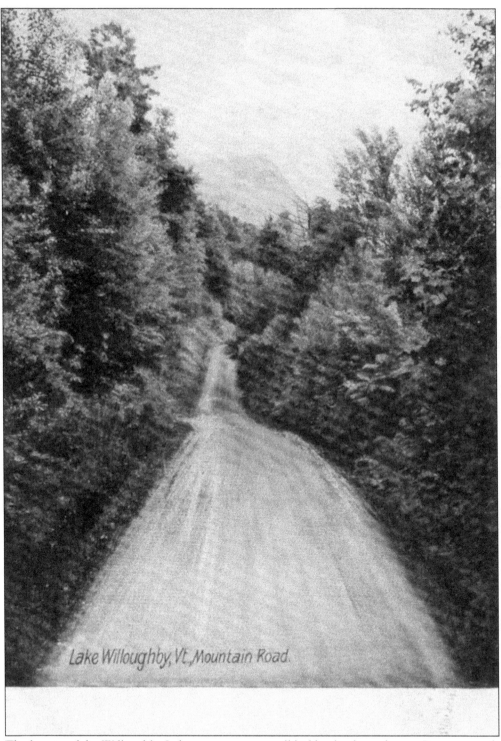

Lake Willoughby, Vt., Mountain Road.

The beauty of the Willoughby Lake area was once well hidden by dense forests. But once roads were broken and fields cleared, the region became more accessible. In this image, Westmore is at its best, in all its natural beauty. (Courtesy of Elaine Bandy.)

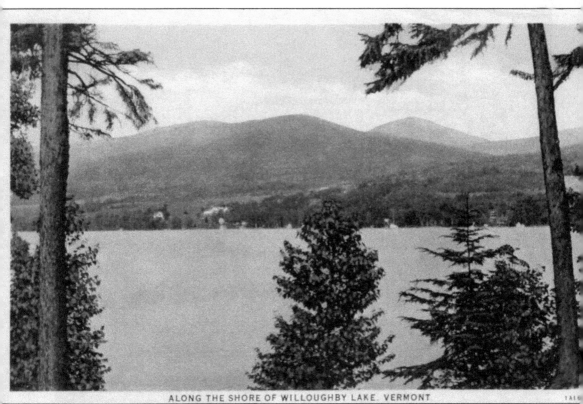

The mountains in the background frame the tranquil blue waters of Lake Willoughby. This card was sent to Mrs. O.E. Ernshaw in Sommington, Connecticut, on July 13, 1937, and reads, "Left Boston at 7:45 last evening. We arrived here at 4:00 or thereabouts. Slept most of the night but it was cold. It's cold here now at 5:30 and just had coffee, but not like some I have had. We leave on the bus for Shirley's at 9:00. The sun is coming out and there is a nice view. I will go out and sit near this beautiful lake instead of the cove. I will write soon and think it will be safe to send any mail to Craftsbury Commons, Vermont. Love to you both. Adams." (Courtesy of Elaine Bandy.)

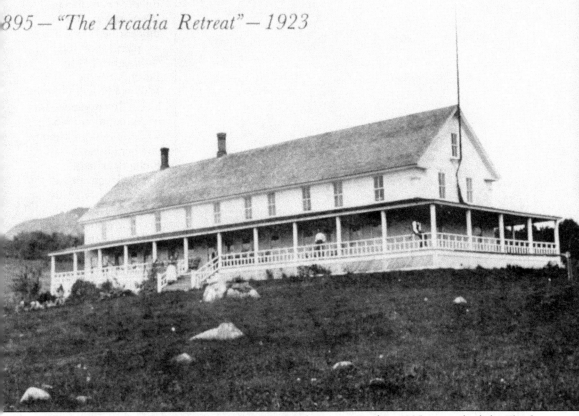

This is the mysterious Arcadia Retreat (1895–1923.) Constructed in 1895, it was built by Floyd Varis of Chicago. It was originally reached by an old road near Long Pond, but later, the town built a road leading directly from the main road. Arcadia Retreat was closed to the public about 1912. For some time, there were wild rumors about the abandoned building. According to the rumors, no human being was around, but a caretaker did look after the horses and the building for a time. A spooky atmosphere must have prevailed when breezes blew gently through the tenantless hotel, slithering papers across the floor and swinging the doors eerily on creaky hinges. In time, even the doors disappeared. People's curiosity was whetted whenever they caught a glimpse of the deserted hotel among the distant treetops on the southerly slope of Mount Pisgah. The building burned in 1923, and whatever the cause, the fire created a spectacular sight and left only the ashes of a once beautifully appointed lodging. Even today, mystery, speculation, and curiosity still flourish whenever Arcadia Retreat is mentioned. This image is from *Willoughby Lake: Legends and Legacies* by Harriet F. Fisher's book. (Courtesy of the Orleans County Historical Society.)

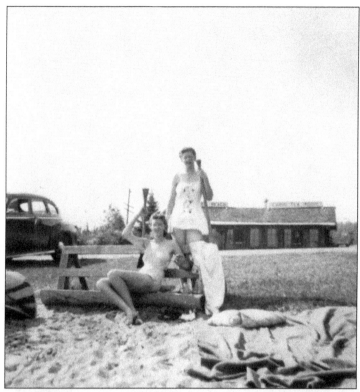

Rebecca Alexander (standing) and an unidentified woman are pictured on the Willoughby North Beach, with the Willoughby Lake Cabin Tea Room in the background, in 1948. Rebecca's sister Eleanor and her husband, Richard, managed the Willoughvale Inn during the late 1940s and early 1950s, and Becky was one of many young men and women who found summer jobs there, with time off between meals to enjoy the beach and water. The Cabin Tea Room was part of the Willoughvale Inn. (Courtesy of the Wayne Alexander family.)

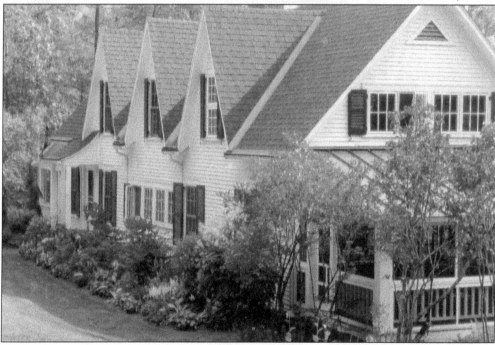

As one can see, this exquisite cottage has been well kept over the years, with just a few minor changes. The gardens around the grounds are always professionally groomed, and there is a perfect vantage point overlooking the lake. This picture was taken in 2015. (Author's collection.)

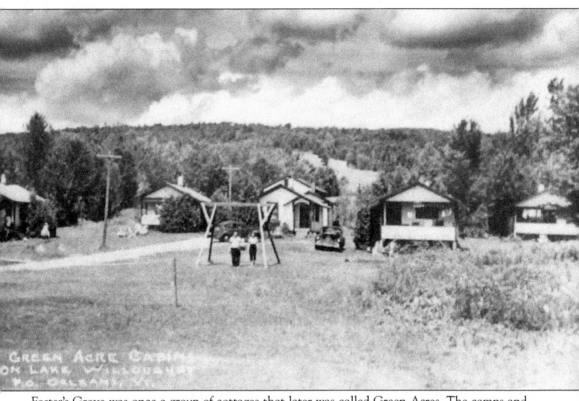

GREEN ACRE CABINS
ON LAKE WILLOUGHBY
P.O. ORLEANS, VT.

Foster's Grove was once a group of cottages that later was called Green Acres. The camps and cottages in this popular area of Vermont now number in the hundreds and are tucked away in and secluded along back roads as well as along the bountiful shores of beautiful Lake Willoughby. (Author's collection.)

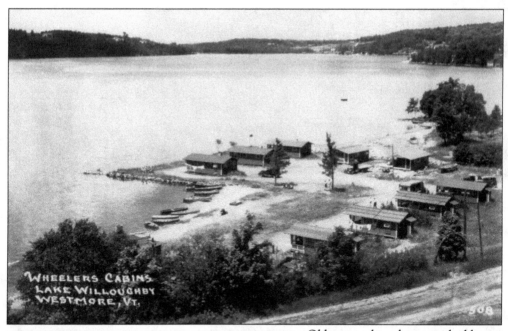

Old cars and trucks are parked by Wheeler's Cabins while several canoes wait to be out on the water at the lake. Shirts and towels on lines dry in the breeze. (Courtesy of Greg Gallagher.)

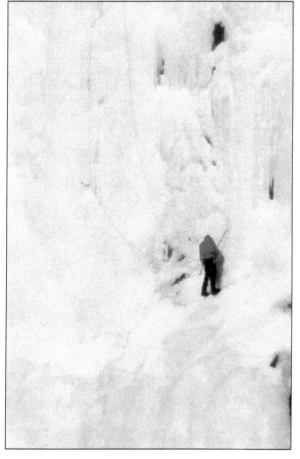

Ice climbing is quite a popular sport on the cliffs high above Willoughby Lake. Ice climbing is risky business, with climbers being secured by ropes and pulleys for safety. (Author's collection.)

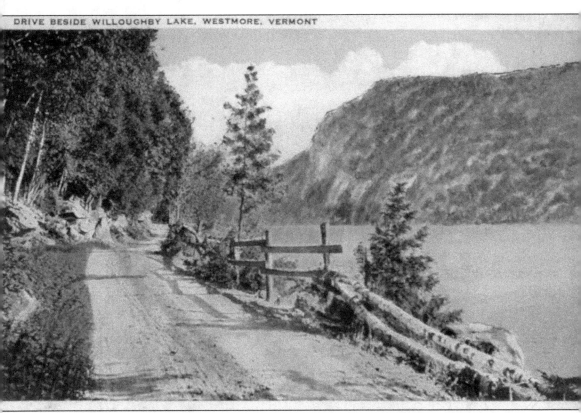

DRIVE BESIDE WILLOUGHBY LAKE, WESTMORE, VERMONT

Dirt roads such as the old Vermont Route 5A were very difficult to navigate in the springtime. The deep, mucky mud would easily make automobiles slither almost uncontrollably. A story was related about Lee Emerson and his wife, Dorcas, traveling to town with his sisters Dorothy and Flora. With limited seating, they had their aunt ride in the back of the truck. They bounced along the muddy road, but their aunt fell off the back of the truck. That must have been quite an experience. This recollection came from Mildred Davis, who has lived in Westmore since 1954. (Courtesy of Elaine Bandy.)

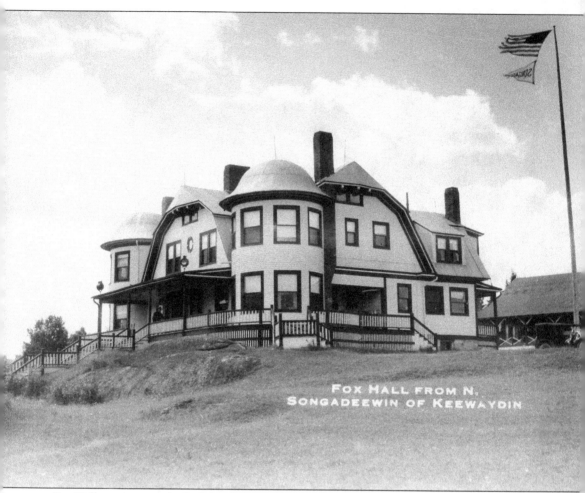

FOX HALL FROM N.
SONGADEEWIN OF KEEWAYDIN

Fox Hall was an estate built about 1900 as a summer home for Mr. and Mrs. John Garrison. It was then owned by a Mr. and Mrs. Peene and changed hands many times through the years. It was sold in 1919 to Russell Bancroft, who operated it as Camp Westmore. With Bancroft failing to make a go of it, the property was obtained by an Orleans antique dealer. (Courtesy of Ken Barber.)

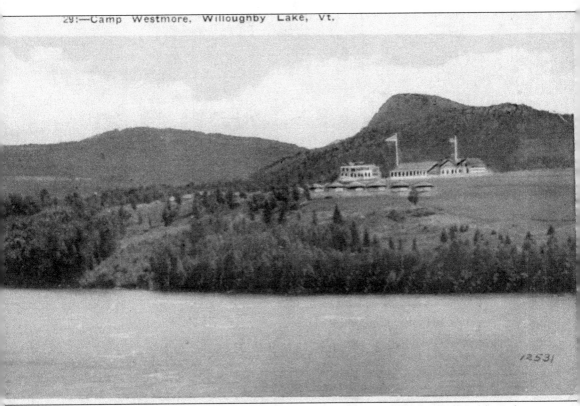

29:—Camp Westmore, Willoughby Lake, Vt.

In 1921, the Keewaydin Camps bought Fox Hall. The Songadeewin camps at Willoughby Lake became an exclusive girls camp and, by 1923, could accommodate 120 girls. The final camp season was in the summer of 1976. (Courtesy of Greg Gallagher.)

From *The Vermonter*, April 1911

Lake Willoughby

Watched over by vast sentinels of rock;
 Surrounded by the gloom of forests deep,
Thy waves leap high in boisterous playfulness
 Or peaceful lie in sleep.

Lovely thou art on calm midsummer days,
 Reflecting azure fields where white clouds roam,
And glorious when the wild winds rise and dash
 Thy waters into foam.

When the glad day departs, and softly steal
 The shades of evening over lake and shore
The hermit thrush then sings her vesper song
 To the dim woods of Hor.

The sunset glory falls on Pisgah's height,
 Clothing that rugged form with beauty rare,
While murmurous waves lap gently on the shore,
 A lullaby to care.

The stars look down on myriad stars below
 In the blue depths, then early haste away
As o'er the hills of morning comes in state
 Another radiant day.

O beauteous lake and forest-laden hills
 Where shadows fall and endless breezes blow,
Almost thou seemest in our troubled age
 An Eden here below.

EVA MARGARET SMITH

92

This poem "Lake Willoughby" was written by Eva Margaret Smith and appears in the April 1911 issue of the *Vermonter* magazine. (Courtesy of the *Vermonter* magazine.)

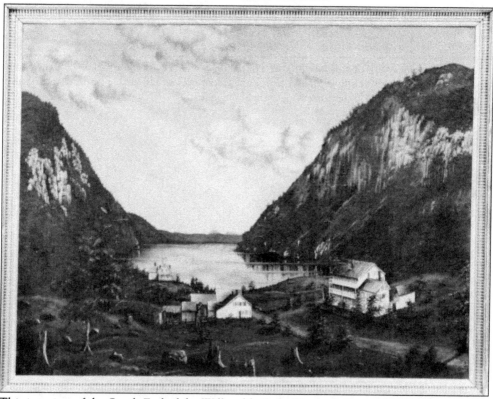

This is a view of the South End of the Willoughby Lake House, built in 1852 and destroyed by fire on November 15, 1904. The artist of this c. 1875 oil painting is unknown. (Courtesy of the Orleans County Historical Society.)

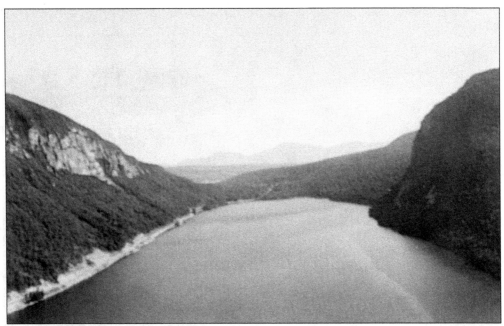

This 1961 aerial view (from an airplane) offers another spectacular picture of Lake Willoughby cupped in between its lovely mountains. The photography was taken by Frank L. Forward. (Author's collection.)

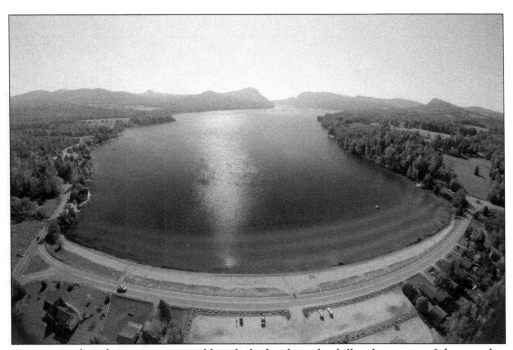

A more complete photogenic view could not be had without the skill and expertise of photographer Jesse Dion. (Courtesy of Jesse Dion.)

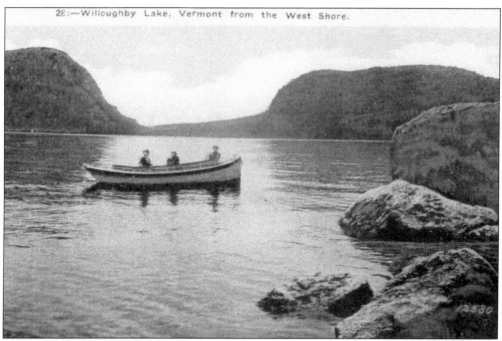

Rowing around the boulders on Willoughby Lake is a great way to spend the day as these three can attest to doing. In this photograph taken from the West Shore, Mount Pisgah and Mount Hor can be seen in the background. (Author's collection.)

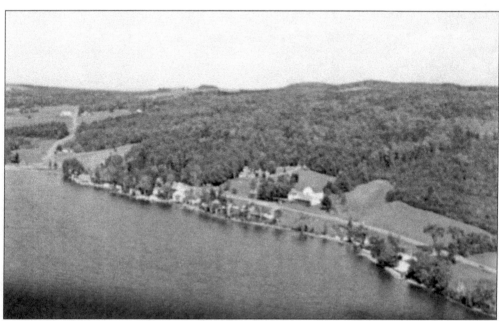

This is a spectacular aerial view of camps along Lake Willoughby, with the Willoughvale in the foreground. (Author's collection.)

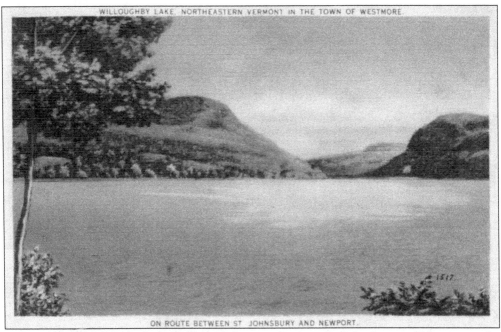

What could be prettier than this picture of the route between St. Johnsbury and Newport in the northeastern town of Westmore? (Courtesy of Kathy Frye.)

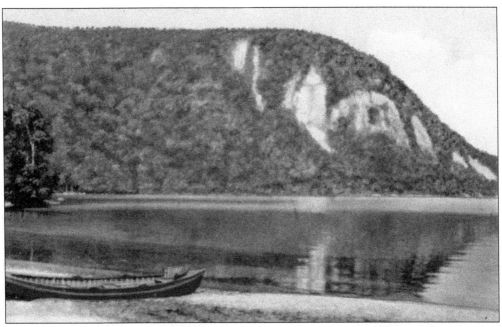

Mount Hor is mirrored in Lake Willoughby and a canoe on the shore awaits its time to glide along the still waters. (Courtesy of Kathy Frye.)

A dark sky threatens rain while the sun shines on trees and camps at the water's edge on Willoughby Lake. (Author's collection.)

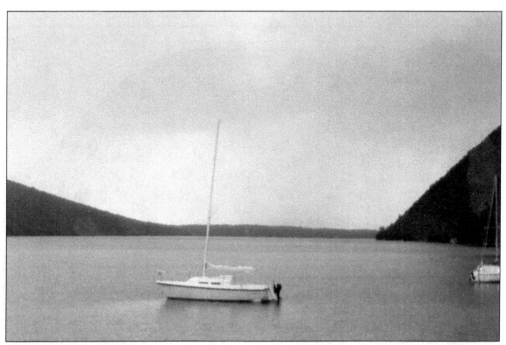

A lonely sailboat is waiting to travel the waters of Lake Willoughby. Such days are usually filled with boats on the lake. (Author's collection.)

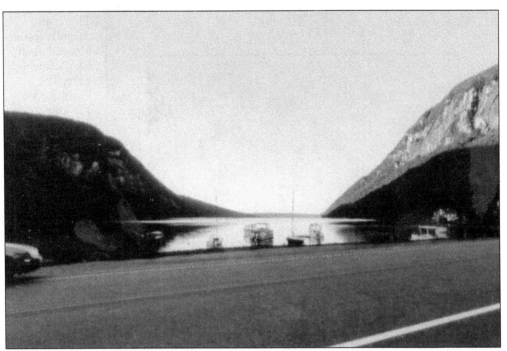

Clear blue skies beam behind a cluster of boats onshore. (Author's collection.)

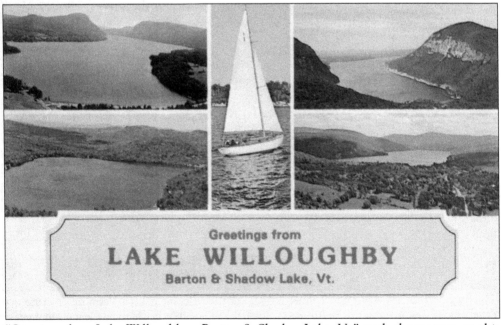

"Greetings from Lake Willoughby—Barton & Shadow Lake, Vt." reads the message on this postcard. (Author's collection.)

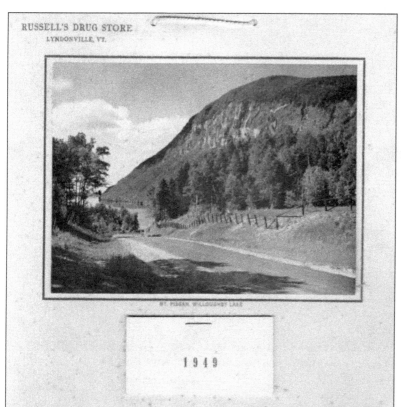

RUSSELL'S DRUG STORE
LYNDONVILLE, VT.

MT. PISGAH, WILLOUGHBY LAKE

1949

This 1949 calendar features Mount Pisgah on Willoughby Lake. The Pisgah Lodge was located farther back on this road. The lodge was originally a nice old farmhouse. (Courtesy of Kathy Frye.)

The back of this card says it all: "Nature has set out the welcome mat, as Vermont's picturesque countryside takes on its mantle of Autumn color. Lake Willoughby is said to be the most impressive in Vermont, if not in the United States." This is a Richardson color photograph. (Courtesy of Kathy Frye.)

A very nice picture of the lake and the park in Westmore is seen on this card. It was sent to Mrs. H.S. Robbins on July 27, 1922, and reads, "Dear Cousins, I am having the time of my life! We were here for tea yesterday on our way home from St. Johnsbury. The whole trip was wonderful, but this place was the very best of all. I leave Florence's Thursday for Lake Winnipesaukee. Love to you both. Percie." (Courtesy of Kathy Frye.)

This 1954 calendar pictures springtime with lovely trees in blossom. (Courtesy of Kathy Frye.)

This very beautiful postcard view shows a straight road traveling by the lake and mountains in the background. (Courtesy of Kathy Frye.)

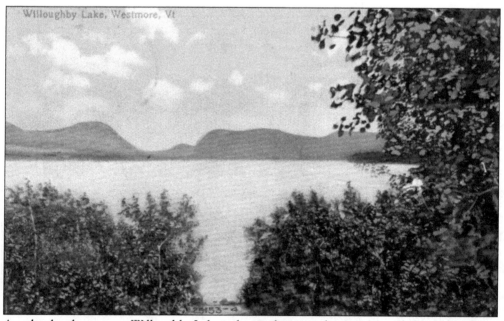

Another lovely scene on Willoughby Lake is depicted on a card sent to Mrs. Elmore Davidson in West Charleston, Vermont, in 1920. (Courtesy of Kathy Frye.)

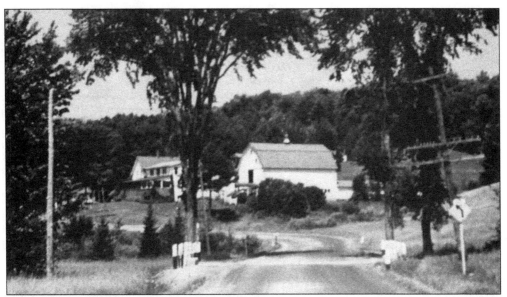

Willoughvale Farm, shown here around 1939, was where Vermont poet Robert Frost and his family camped out in 1909. Note the stately elms on either side of the road. This farm was originally called the George Conley farm. (From *Willoughby Lake: Legends and Legacies* by Harriet F. Fisher.)

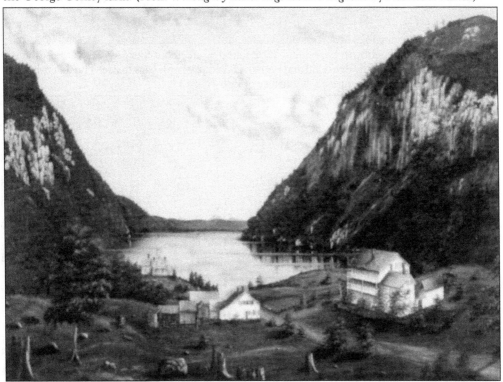

This south end scene of Willoughby Lake was painted in 1875 by an unknown artist. It is a very pristine scene, with the Cheney House on the left looking like a fairy-tale castle. The Lake House is on the right, and Pisgah Lodge is directly across from the hotel. (Courtesy of the Orleans County Historical Society.)

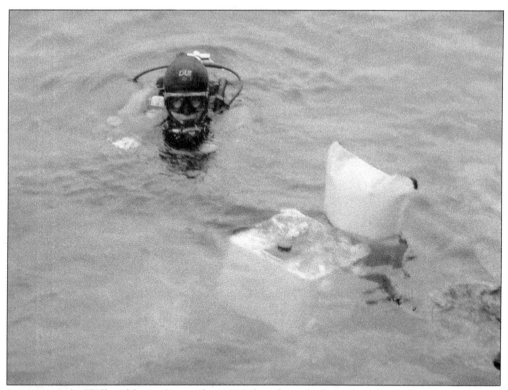

Divers in Lake Willoughby in September 2000 found a safe about four feet below the surface of the lake. The safe was badly damaged and had several empty bank bags inside. The divers hitched a lift bag and took it to the surface. (Courtesy of Bob Guest.)

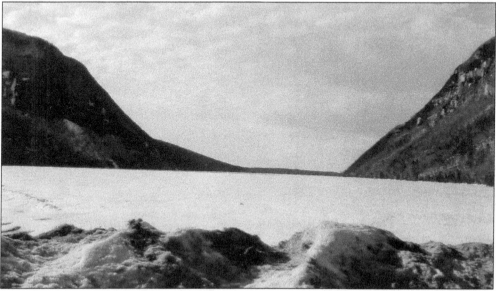

The water temperature of Willoughby does not change much below about 40 feet during the year. In the summer, it is about 46 degrees, and in the winter, it drops a little lower, to 41 or 42 degrees. The surface temperature during the winter is about 32 degrees. Divers wear dry suits year-round, and in the winter, they add more insulation for warmth. (Author's collection.)

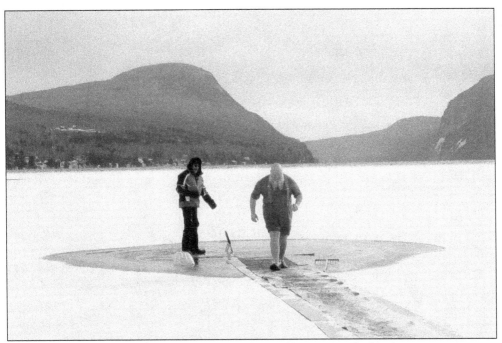

In the town of Westmore, a large crowd gathers along with organizer Fred Laferriere to commence the annual Lake Willoughby dip on New Year's Day. This fundraiser started in 2003 to honor Laferriere's brother, Jesse, who died of cancer at age 54. (Courtesy of Steve Morse.)

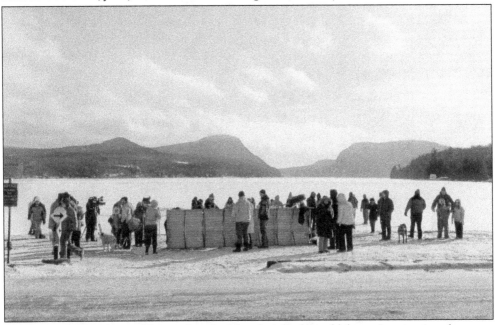

The large crowd gathers at the north end of the glacially formed lake on January 1 each year at 1:00 p.m. Along with the volunteer plungers, there are ambulance personnel, emergency workers, and members of the press as well as family, friends, and many well-wishers gathered on the shore of North Beach. A bonfire is provided along with a changing van for the volunteers. (Courtesy of Steve Morse.)

Visit us at
arcadiapublishing.com

......................................